SKETCHES OF SAI KUNG

Lorette E. Roberts

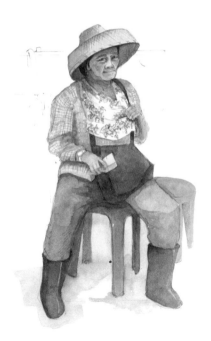

BLACKSMITH BOOKS

SKETCHES OF SAI KUNG

ISBN: 978-988-99799-6-6

First published October 2007
Reprinted May 2013

Published by Blacksmith Books
Tel: (+852) 2877 7899
5th Floor, 24 Hollywood Road, Central, Hong Kong
www.blacksmithbooks.com

Stylised Chinese characters on jacket by Wee Kek Koon

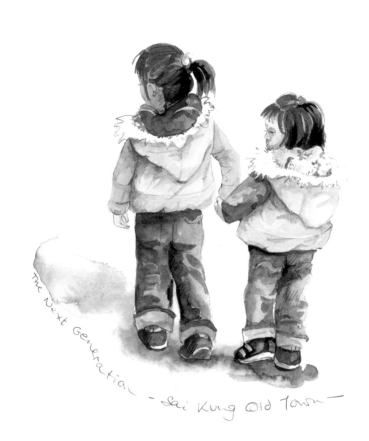

The Next Generation – Sai Kung Old Town –

FOREWORD

Much of the beauty of Sai Kung lies hidden from the bustling weekend town; the stunningly beautiful beaches of Tai Long and Long Ke, dramatic cliff-lined offshore islands and a plethora of underwater marine life with colourful corals and myriads of small fish on nearby reefs. Lying beneath the towering peak of Ma On Shan, Sai Kung is surrounded by country parks and sparkling seawater; call it an outdoor adventure playground or a green escape, Sai Kung is a unique surprise considering its closeness to the hectic and noisy areas of Kowloon and Central.

These picture-postcard settings are only part of what Sai Kung has to offer. From Tin Hau temples to a bustling waterfront, from Old Sai Kung to New Sai Kung, from white sandy bays to Millionaires Bay, from al fresco dining to extravagant seafood, a diversified local and expatriate community, Sai Kung has it all. One can see why the district has been chosen to be part of the 'Sketches' series. This book beautifully illustrates why so many people choose to visit and live in Sai Kung.

Whatever your passion or zest for life, visit Sai Kung and explore what it has to offer; it's a tough place to leave at the end of an energetic day.

西貢的美往往隱藏在熙來攘往的周末都市中，大浪灣及浪茄那美得叫人眩目的海灣，島嶼臨海遍佈雄偉的崖壁，海底擁有不盡的海洋生態，包括色彩斑斕的珊瑚及近鄰礁群上無數各式各樣的小魚。

西貢躺臥在高聳的馬鞍山下，被郊野公園和閃爍的海水包圍著；不管我們稱它為戶外冒險樂園抑或是綠洲樂土，毗鄰緊張和嘈雜的九龍及中環的西貢，總是給人一份與眾不同的驚喜。

這些明信片般的如畫景致，只是西貢的一部份。從天后廟到熙攘的海濱，由老西貢到新區，自白沙灣至"大亨灣"，從露天食肆到奢華的一頓海鮮餐，多元化的本地及外國人社區，西貢通通都擁有。你可以從中了解為何這個地方會被選成為"素描寫生"系列的一員，而此畫冊漂亮的素描亦闡明了為何那麼多人會選擇到訪或居住在西貢。

無論你的追求和興味是甚麼，也應該來一趟西貢看看有甚麼適合的東西；你將會發現，這是一處在徜徉一天以後就難以離去的地方。

<div align="right">

Charles Frew
Sai Kung Association 西貢協會

</div>

This sketchbook is for Amelia, Guy and Alissia who, despite having a crazy artist for a mother, have turned out just fine!

ACKNOWLEDGEMENTS

One of the best parts of finishing a sketchbook is thinking of all the people who have helped me bring the project to fruition. I must particularly thank the Hong Kong youngsters from a boarding school near my home in Suffolk for their help with translation. So, Lynn Campbell, Pete Spurrier, Karina Cavalcanti, Fiona Cheung, Irene Lau, Lauralynn and Tom Goetz, Thomas Tang, Colette Li, Ian Tsang, Lu Hui, Doug Moore, Susie and Patrick Budden, Rosanna Pindoria, WOW!, Wee Kek Koon, Chris Davis and Gladys Ng... thank you!

As usual, I ask and thank the reader for leniency in judging my Chinese characters. And meanwhile, if you think you recognize yourself in a sketch, thanks for being so interesting!

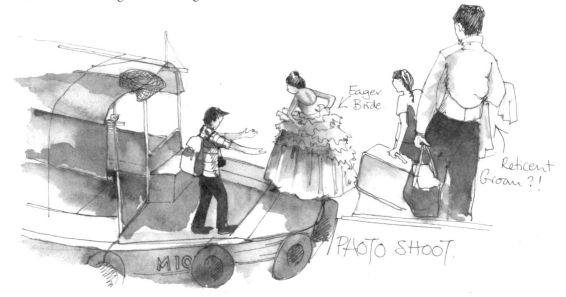

Eager Bride

Reticent Groom ?!

PHOTO SHOOT.

JUST TO SAY...

...that for me, the timeless charm of Sai Kung lies in its relative isolation, which endures while Tseung Kwan O at the southern tip of the district has changed dramatically in the past few years into a vibrant new town. How amazing that both were originally tiny fishing villages, and both recently expanded onto reclaimed land, and yet they are so different! The whole area, from the Sai Kung country parks to the Clear Water Bay peninsula, is one of contrasts, with one thing in common: a natural backdrop of the sea and a myriad islands.

I have visited fish markets, open-air restaurants, nature reserves and enchanting villages (old, new, resited and abandoned); seen HKUST, reservoirs, salt fields, lime kilns, UNESCO heritage sites and film studios; watched people busy with kite flying, wakeboarding, fishing and tackling the MacLehose Trail; enjoyed junk trips, travelled on sampans and been flabbergasted by the unofficial pampered pooch parade one Sunday afternoon on Sai Kung promenade!

This book of sketches is an eclectic collection of my personal choices from the unusual and mysterious to the vernacular. Of course it includes the ubiquitous postboxes, but it boasts its own unique collection of bus stops and plenty of concealed snails!

… 對於我來說,西貢永恆的魅力在於與其他地方相對隔絕,在將軍澳區南部近年急劇發展成為活躍的新市鎮的同時,它不為所動地保留了原有的面貌。兩地本來也是細小的漁村,同時擴展新填海的土地,然而兩者竟爾如此的不同!西貢到處都充滿著不同的對比,西貢郊野公園與清水灣半島的大不同只是其中之一,然而儘管如此,整個地區有一點是共通的:就是舉目所見,不管那裡均擁有無數美麗的海島和大自然作背景。

我到訪過魚市場、露天酒樓、自然水庫、迷人的小漁村(舊的、新的、轉了新址的、棄置的);看過香港科技大學、水塘、鹽田、石灰窰、聯合國教科文組織的世界遺址、及電影攝影棚;觀察過往來的人群忙著在放風箏、滑水、釣魚、及遠足於麥理浩徑;享受過沙灘和遊船河、乘過舢舨,更在一個周日下午於西貢散步時,目瞪口呆地看到一眾人不約而同地聯合放狗,即場演出了一幕非官方的愛犬巡遊!

此畫冊的素描寫生綜合了我的最愛,其中包括了我對非一般和神秘的事物以至對本土地道物品的個人選擇。當然素描也少不了在西貢隨處可見的郵筒,但這畫冊最引以為傲的,卻是那獨特的巴士站系列,以及大量隱蔽的蝸牛大隊!

Loretta

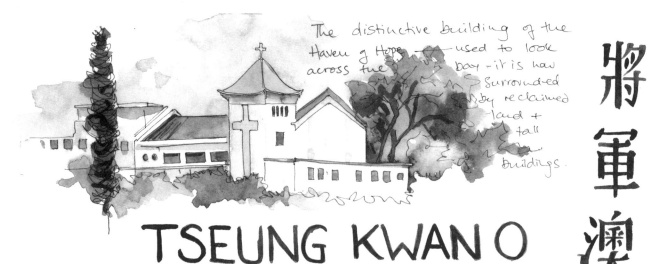

The distinctive building of the Haven of Hope — used to look across the bay — it is now surrounded by reclaimed land + tall buildings.

將軍澳

TSEUNG KWAN O

"Once upon a time, there was a 600 yr. Old village in the South of SAI KUNG District — called Tseung Kwan O — where the inhabitants spoke their own dialect & Caught hapless Owls to make biltong —

The vision to create the vast New Town was approved in 1982 — This Vertical village now covers ± 10.05 km²

The Name TSEUNG KWAN O may be translated as "General's Bay" possibly after the visit of a Ming dynasty General or may refer to Naval battles fought against Pirates in the 17 — more Intriguing — but Shouldit or be "Admirals Bay?"

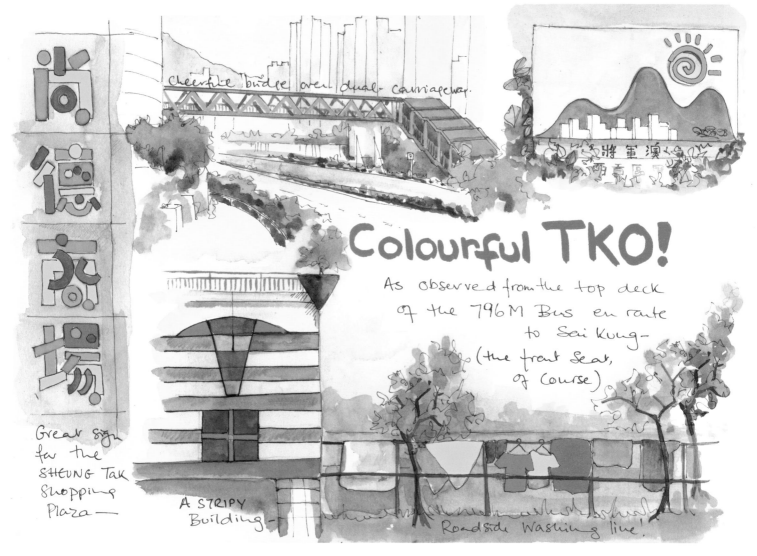

Cheerful bridge over dual-carriageway.

尚德廣場

将軍澳

Colourful TKO!

As observed from the top deck of the 796M Bus en route to Sai Kung — (the front seat, of course)

Great sign for the SHEUNG TAK Shopping Plaza —

A STRIPY Building —

Roadside Washing line!

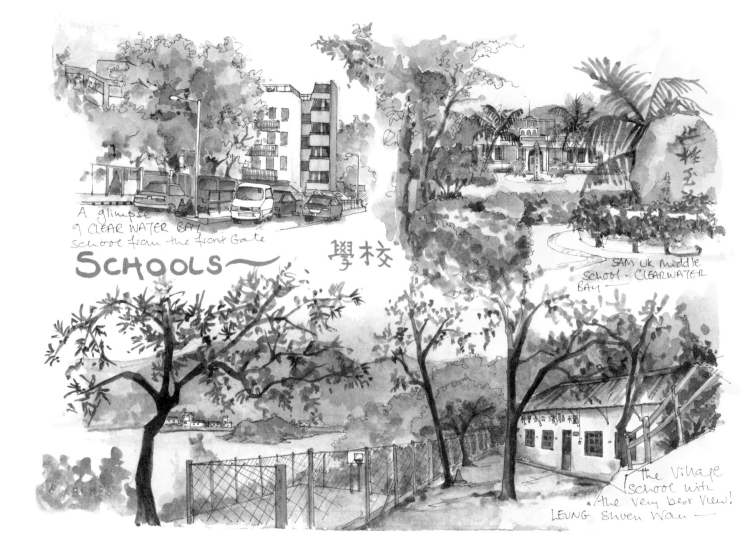

A glimpse
of CLEAR WATER BAY
school from the front gate

SCHOOLS~

學校

SAM UK middle
SCHOOL - CLEARWATER
BAY

the village
school with
the very best view!
LEUNG SHUEN WAN

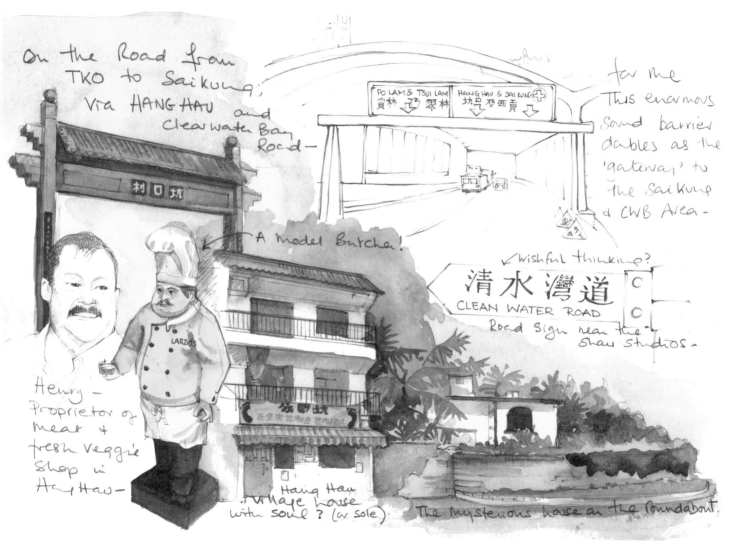

On the Road from TKO to Saikung, via HANG HAU and Clear Water Bay Road —

PO LAM & TSUI LAM 寶林 翠林
HANG HAU & SAI KUNG 坑口及西貢

for me This enormous Sound barrier doubles as the 'gateway' to the Sai kung & CWB Area —

村口坊

A Model Butcher!

←Wishful thinking?

清水灣道
CLEAN WATER ROAD
Road Sign near the Shaw studios.

LARDOS

Henry — Proprietor of meat + fresh veggie shop in Hang Hau —

茶餐城

Hang Hau village house with soul? (or sole).

The Mysterious house on the roundabout.

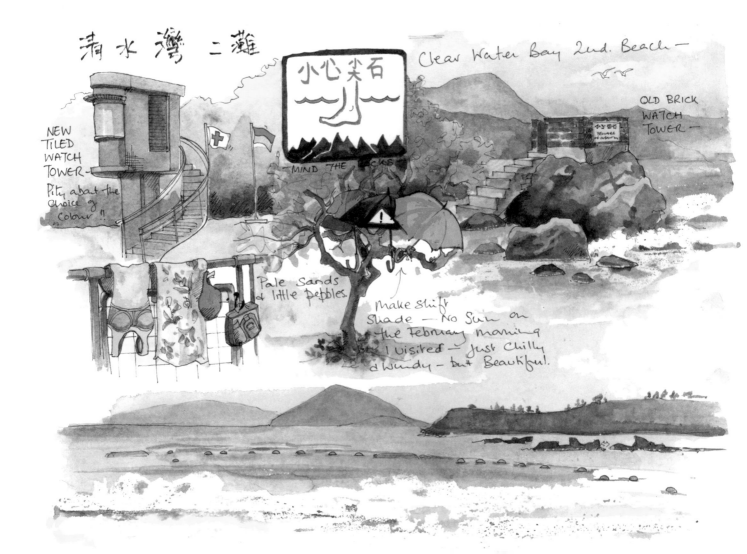

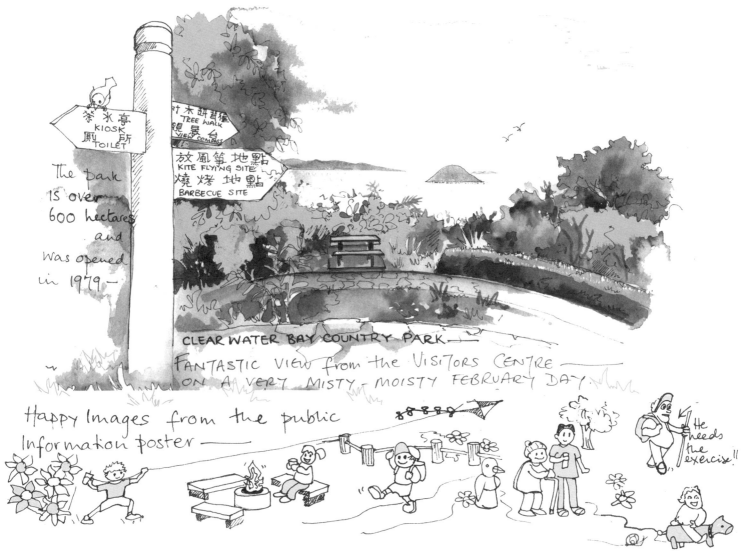

茶水亭 KIOSK
廁所 TOILET

計木研徑 TREE WALK
觀景台 VIEW COMPASS

放風箏地點 KITE FLYING SITE
燒烤地點 BARBECUE SITE

The Park is over 600 hectares and was opened in 1979 —

CLEAR WATER BAY COUNTRY PARK —

FANTASTIC VIEW from the VISITORS CENTRE ON A VERY MISTY - MOISTY FEBRUARY DAY.

Happy Images from the public Information poster —

He needs the exercise!!

釣魚翁

Hope that is right — it
kept fluttering
around —

"Red-base Jezebel"

MELASTOMA CANDIDUM

HIGH JUNK PEAK

Sketching on the hoof —
names came later —

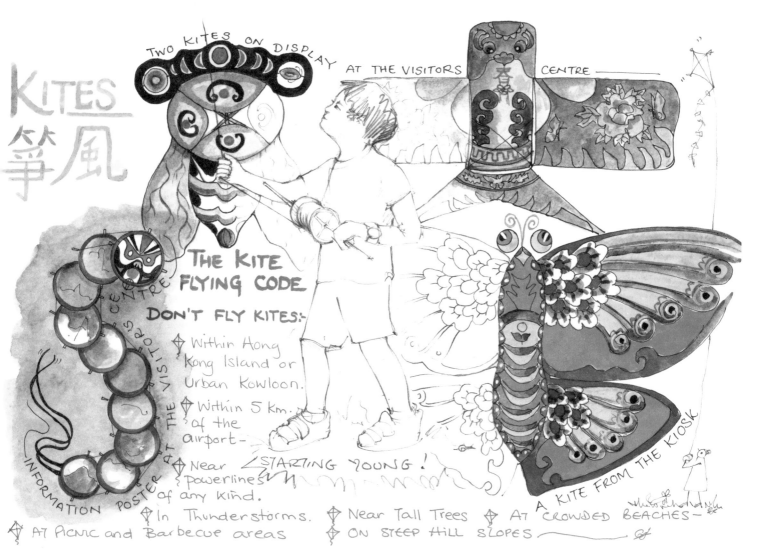

KITES
箏風

TWO KITES ON DISPLAY AT THE VISITORS CENTRE

THE KITE FLYING CODE

DON'T FLY KITES:

- ◈ Within Hong Kong Island or Urban Kowloon.
- ◈ Within 5 km. of the airport—
- ◈ Near powerlines of any kind.
- ◈ In Thunderstorms.
- ◈ At picnic and Barbecue areas
- ◈ Near Tall Trees
- ◈ On steep hill slopes
- ◈ At crowded beaches—

STARTING YOUNG!

INFORMATION POSTER AT THE VISITORS CENTRE

A KITE FROM THE KIOSK

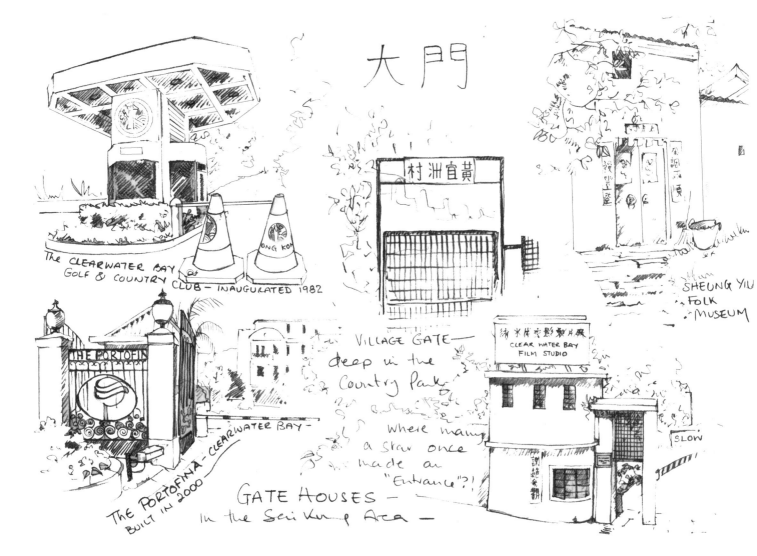

大門

THE CLEARWATER BAY
GOLF & COUNTRY CLUB — INAUGURATED 1982

村洲宜黃

SHEUNG YIU
FOLK
MUSEUM

THE PORTOFINO
— CLEARWATER BAY —

THE PORTOFINA — CLEARWATER BAY
BUILT IN 2000

VILLAGE GATE —
deep in the
Country Park

— CLEARWATER BAY —

where many
a star once
made an
"Entrance"?!

CLEAR WATER BAY
FILM STUDIO

SLOW

GATE HOUSES —
In the Sai Kung Area —

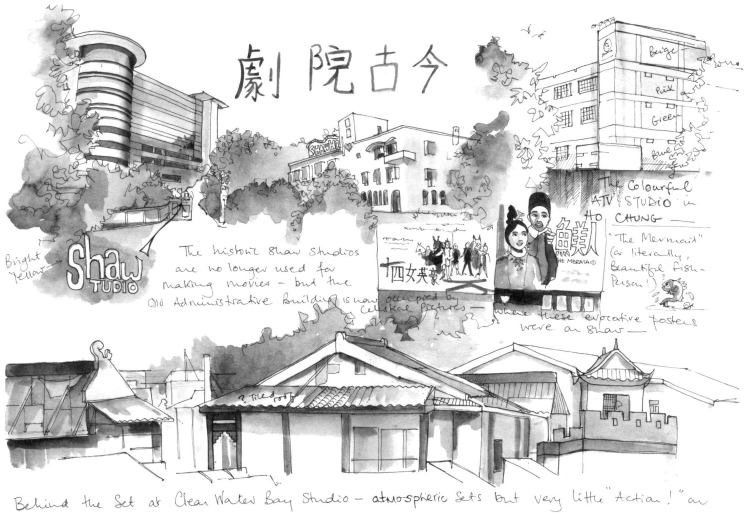

劇院古今

Bright Yellow

Shaw STUDIO

Beige

Pink

Green

Blue

The Colourful ATV STUDIO in HO CHUNG

The historic Shaw Studios are no longer used for making movies — but the Old Administrative Building is now occupied by Celestial Pictures — where these evocative posters were on show —

SHAW

十四女英豪

THE MERMAID 魚美人

"The Mermaid" (a literally beautiful fish-Person!)?

Behind the Set at Clear Water Bay Studio — atmospheric sets but very little "Action!" on this occasion —

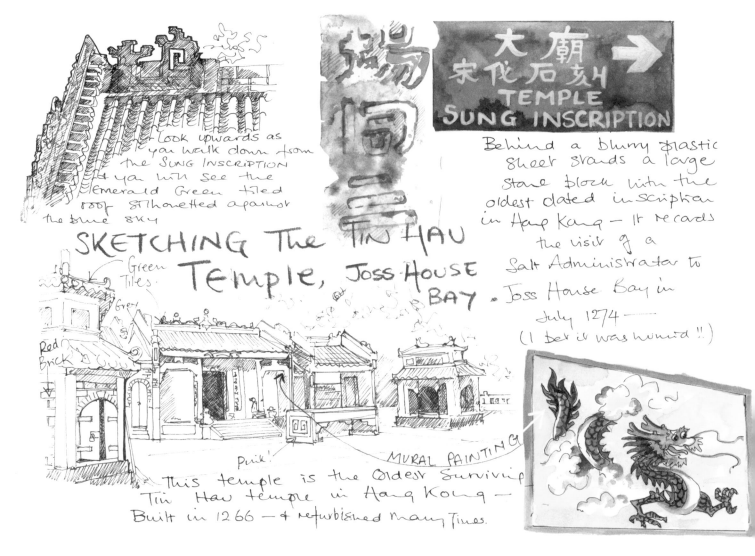

大廟
宋代石刻
TEMPLE
SUNG INSCRIPTION

Look upwards as you walk down from the SUNG INSCRIPTION & you will see the emerald Green tiled roof silhouetted against the blue sky

Behind a blurry plastic sheet stands a large stone block with the oldest dated inscription in Hong Kong — It records the visit of a Salt Administrator to Joss House Bay in July 1274 — (I bet it was humid !!)

SKETCHING The TIN HAU Temple, JOSS HOUSE BAY .

Green Tiles.

Grey

Red Brick

Pink!

MURAL PAINTING

This temple is the oldest surviving Tin Hau temple in Hong Kong — Built in 1266 — & refurbished many Times.

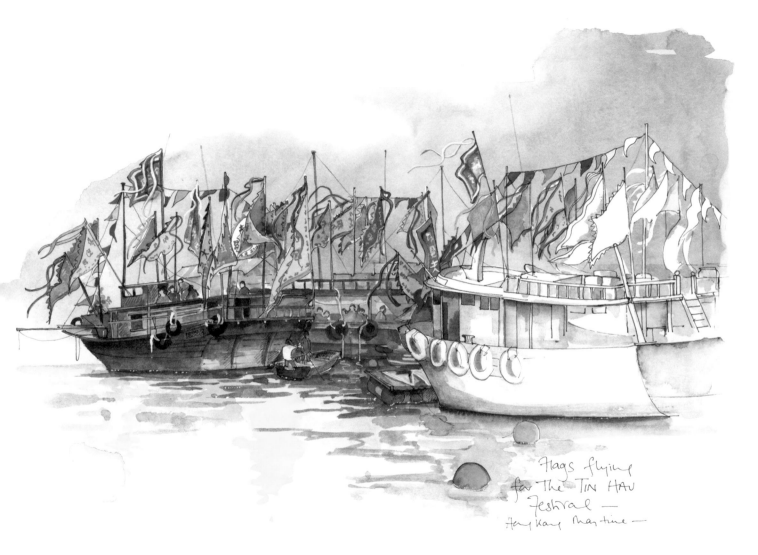

Flags flying
for The TIN HAU
Festival —
Hong Kong Maritime —

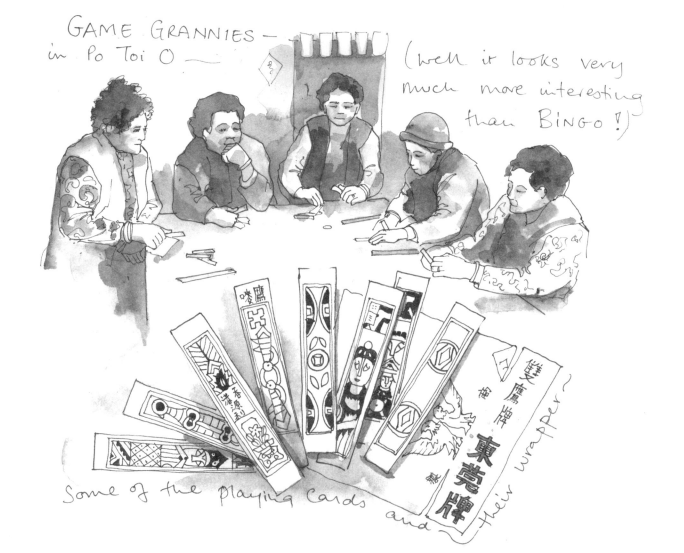

GAME GRANNIES —
in Po Toi O —

(well it looks very
much more interesting
than BINGO!)

Some of the playing cards and their wrapper —

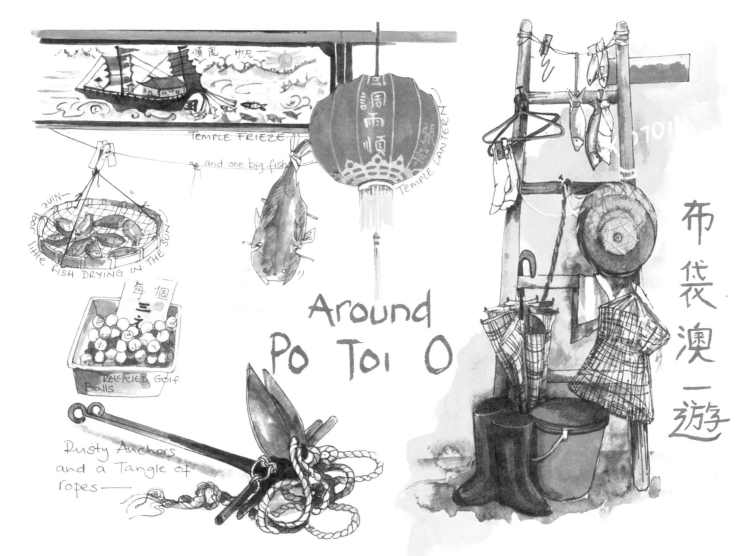

TEMPLE FRIEZE

...and one big fish

JON AUN—
little FISH DRYING IN THE SUN

TEMPLE LANTERN

每 個 三 元

REFACIED GOLF
Balls

Around
Po Toi O

Rusty Anchors
and a Tangle of
ropes—

布袋澳一遊

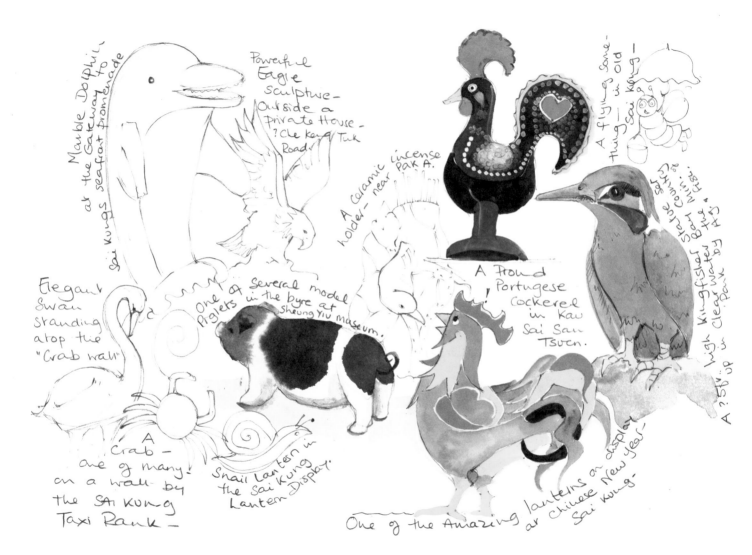

Marble Dolphin at the Gateway to Sai Kung's seafront promenade

Powerful Eagle sculpture — Outside a private House — ? Che Keng Tuk Road.

A ceramic incense holder — near PAK A.

A flying something — in old Sai Kung —

A Proud Portugese Cockerel in Kau Sai San Tsuen.

A statue of "kingfisher" — near Come... min...

A Kingfisher the fish. A ?5ft high up in Clearwater by A's Park

Elegant Swan standing atop the "Crab wall"

One of Several model Piglets in the byre at Sheung Yiu museum.

A Crab — one of many! on a wall by the SAI KUNG Taxi Rank —

Snail Lantern in the Sai Kung Lantern Display.

One of the Amazing lanterns on display at Chinese New year — Sai Kung.

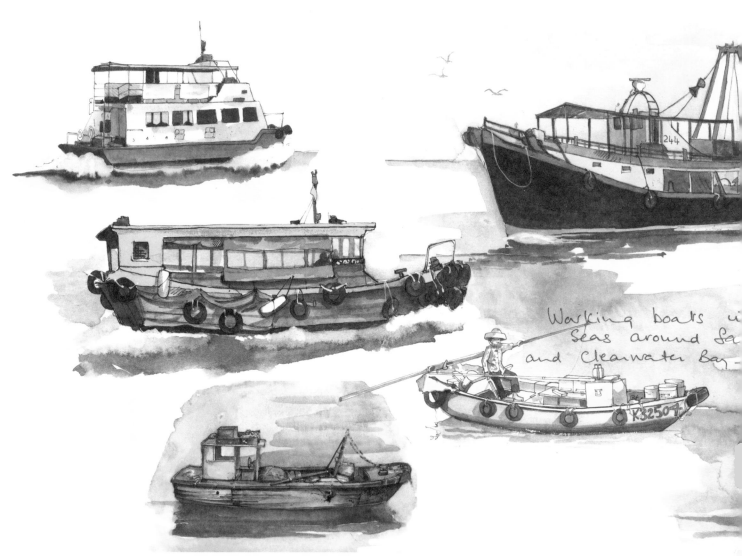

Working boats i
seas around fa
and Clearwater Bay

244

K3250 7

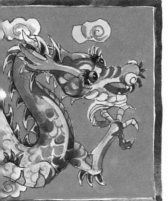

Tin Hau Temple - Sai Kung.

Pak Sa O

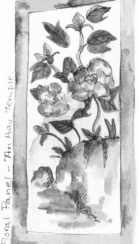

Floral Panel - Tin Hau Temple.

Painted Concrete Bat -

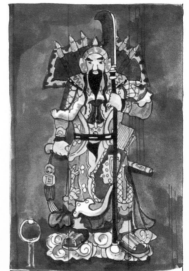

Door God - Pak A.

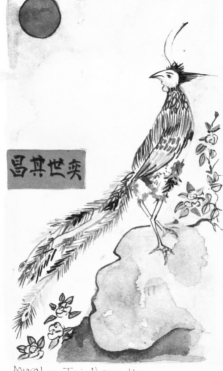

Mural - Tai Hang Hau.

Painted Rafter - Private House -

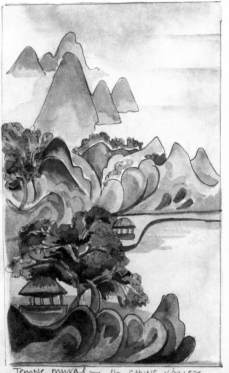

Temple mural — Ho CHUNG VALLEY.

Painted Frieze above a temple door — To Toi O.

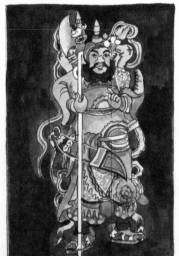

Door God — Tap Mun.

Above a door — Pak Sha O.

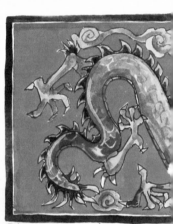

Painted Board above doorway

Painted Pillar — Pak Sha O.

Painted Panel — To Toi O.

Bat Design —

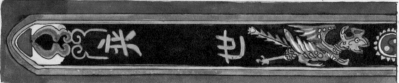

Painted Roof Rafter — Tai Hang Hau.

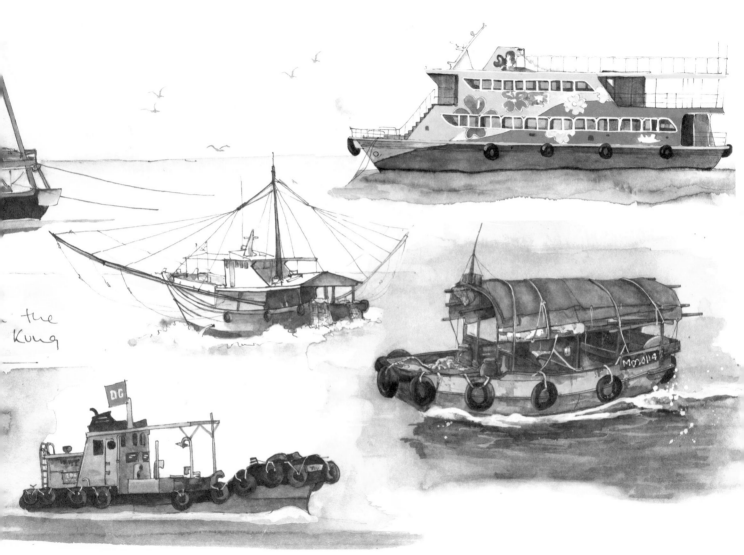

the
Kung

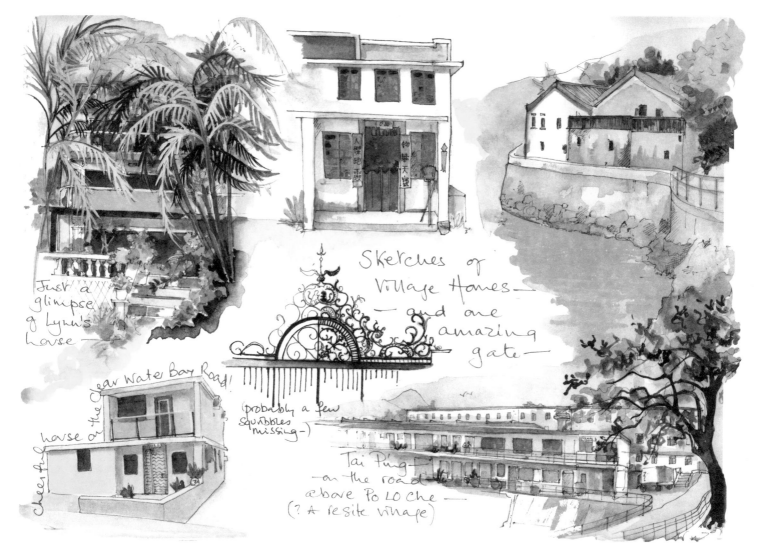

Sketches of
Village Homes —
— and one
amazing
gate —

Just a
glimpse
of Lynn's
house —

(probably a few
squibbles
missing —)

house on the Clear Water Bay Road!

Cheerful

Tai Ping —
— on the road
above Po Lo che —
(? a resite village)

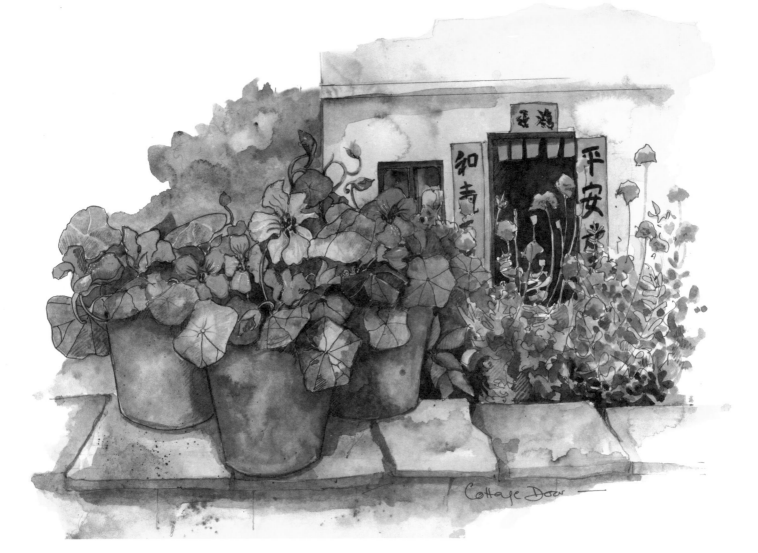

和壽

平安

蛋鷄

Cottage Door

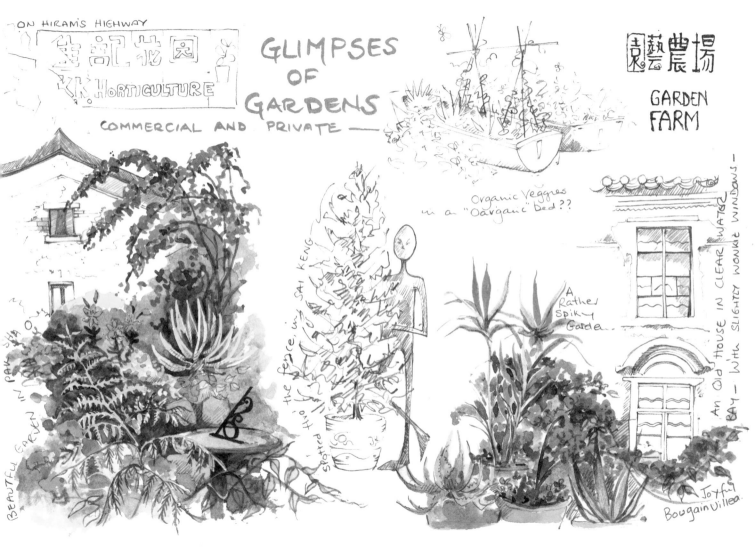

ON HIRAM'S HIGHWAY

鍾記花園
HORTICULTURE

GLIMPSES
OF
GARDENS

COMMERCIAL AND PRIVATE —

園藝農場
GARDEN
FARM

Organic Veggies
in a "Oorganic" bed ??

BEAUTIFUL GARDEN IN PAK SHA O

the fence, way SAI KENG
two spotted

A Rather
Spiky
Garden

An old House in clear water
bay — with slightly wonkie windows —

Joyful
Bougainvillea.

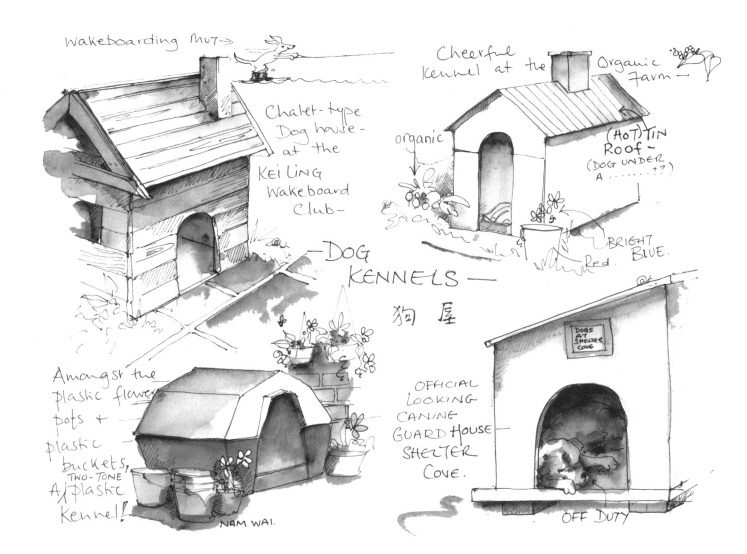

Wakeboarding Mut→

Cheerful Kennel at the Organic Farm—

Chalet-type Dog house- at the KEI LING Wakeboard Club-

organic

(HOT) TIN ROOF— (DOG UNDER A??)

BRIGHT Red. BLUE.

— DOG KENNELS —

狗 屋

Amongst the plastic flowers pots + plastic buckets, TWO-TONE A/ plastic Kennel!

NAM WAI.

OFFICIAL LOOKING CANINE GUARD HOUSE SHELTER COVE.

DOGS AT SHELTER COVE

OFF DUTY

WOW!

HUGE FEET!

A Profusion of PAMPERED POOCHES

Any Sunday Afternoon on Sai Kung sea-front!!

PRECARIOUSLY BALANCED!

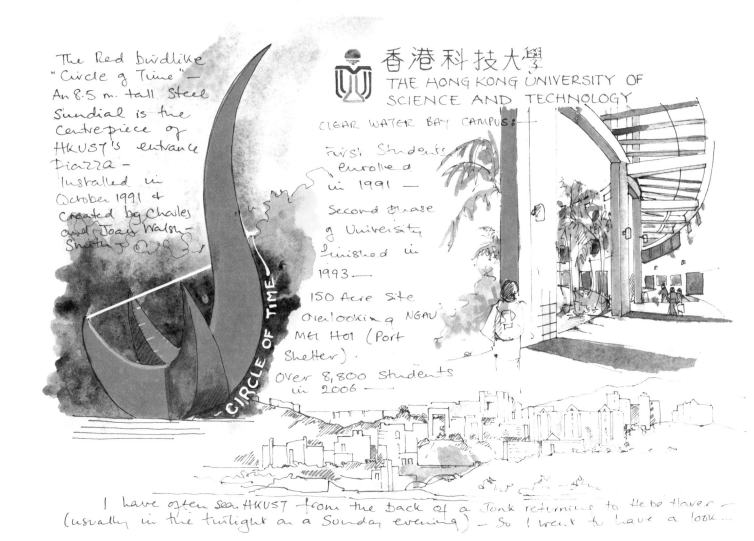

The Red birdlike "Circle of Time" — An 8.5 m. tall Steel Sundial is the Centrepiece of HKUST's entrance Piazza — Installed in October 1991 & created by Charles and Joan Walsh-Smith —

CIRCLE OF TIME

香港科技大學
THE HONG KONG UNIVERSITY OF SCIENCE AND TECHNOLOGY

CLEAR WATER BAY CAMPUS:—

First Students enrolled in 1991 —

Second Phase of University finished in 1993 —

150 Acre Site overlooking NGAU MEI HOI (Port Shelter).

Over 8,800 Students in 2006 —

I have often seen HKUST from the back of a Junk returning to Hebe Haven — (usually in the twilight on a Sunday evening) — So I went to have a look ...

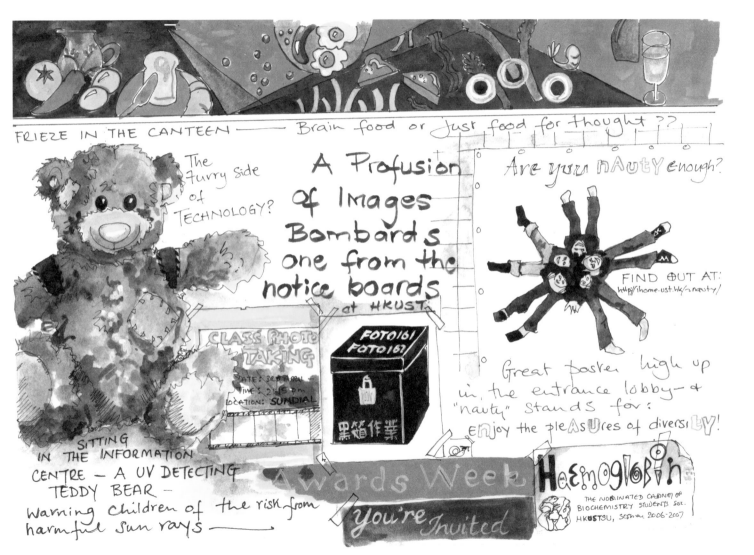

FRIEZE IN THE CANTEEN — Brain food or just food for thought??

The furry side of TECHNOLOGY?

A Profusion Of Images Bombards one from the notice boards at HKUST.

Are you nAUty enough?

FIND OUT AT:
http://ihome.ust.hk/~nauty/

Great poster high up in the entrance lobby — & "nauty" stands for: Enjoy the pleAsUres of diversiLtY!

CLASS PHOTO TAKING
DATE: 3RD APRIL
TIME: 2:15 PM
LOCATION: SUNDIAL

FOTO161
FOTO163
黑箱作業

SITTING IN THE INFORMATION CENTRE — A UV DETECTING TEDDY BEAR — Warning children of the risk from harmful sun rays —

Awards Week
You're Invited

HaEmoglobin
THE NOMINATED CABINET OF BIOCHEMISTRY STUDENTS Soc.
HKUSTSU, Session 2006-2007

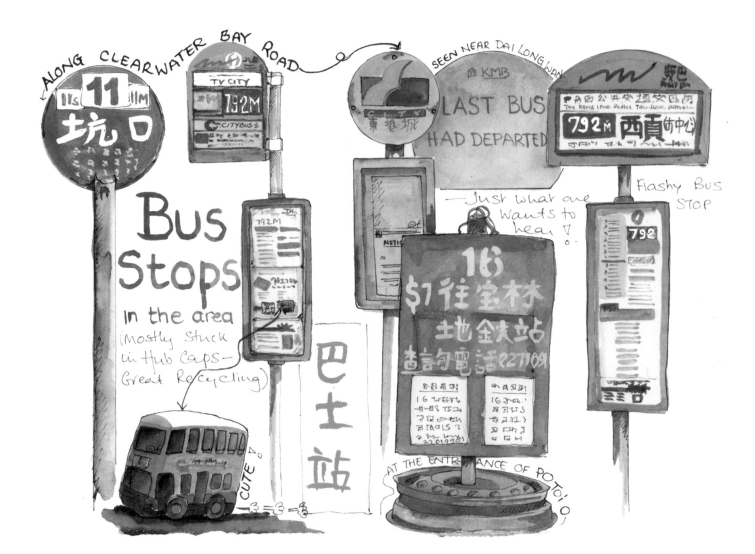

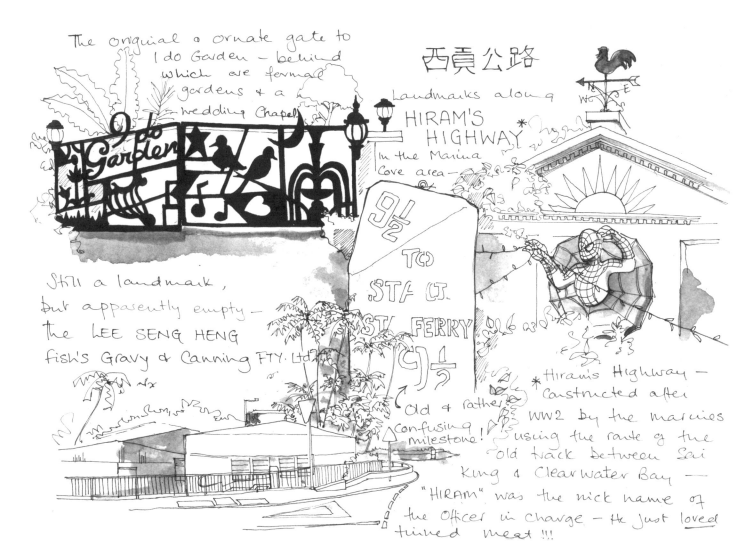

The original & ornate gate to I do Garden — behind which are formal gardens & a wedding Chapel

西貢公路

Landmarks along HIRAM'S HIGHWAY *

In the Marina Cove area —

I do Garden

Still a landmark, but apparently empty — the LEE SENG HENG fish's Gravy & Canning FTY. Ltd

9½ TO STA [J. ST FERRY C] 1½

Old & rather confusing milestone!

* Hiram's Highway — Constructed after WW2 by the marines using the route of the old track between Sai Kung & Clearwater Bay — "HIRAM" was the nick name of the Officer in charge — He just loved tinned meat !!!

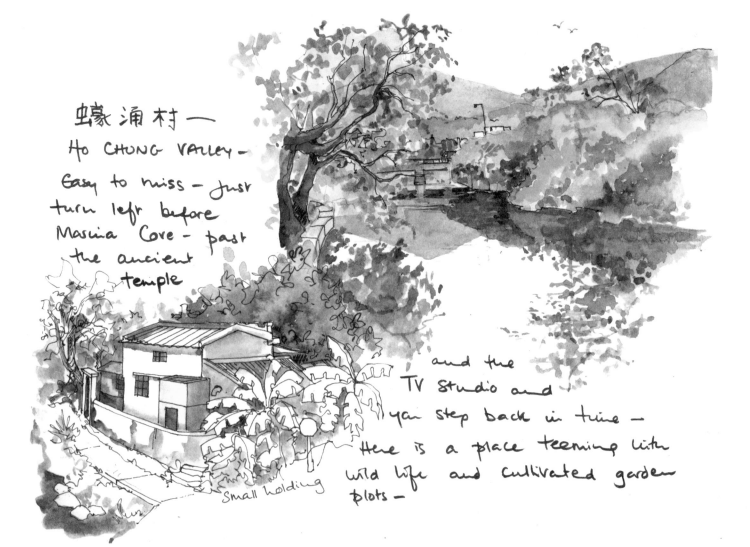

蠔涌村—

Ho CHUNG VALLEY—

Easy to miss — just
turn left before
Marina Cove — past
the ancient
temple

and the
TV Studio and
you step back in time —
Here is a place teeming with
wild life and cultivated garden
plots —

Small holding

CHWAWARE MARKET →

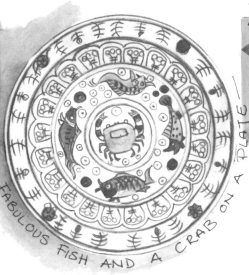

Four Fabulous Fish and a Crab on a Plate

← CHINAWARE MARKET THUR SAT OPEN TIME = 10·00 AM — 4·30 PM

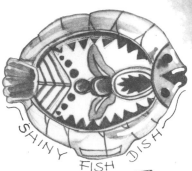

SHINY FISH DISH

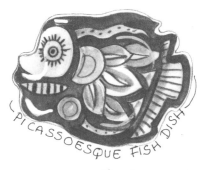

PICASSOESQUE FISH DISH

From 10 'til 4.30
The Shopkeeper sits, with Earphones & paper —
In his Aladdin's Cave of Blue and White china —
Waiting for his Customers —
I made the pilgrimage, following the yellow signs, Up & —
Tho' the village — I gazed, amazed at the array,
& bought a Cheese Dish!

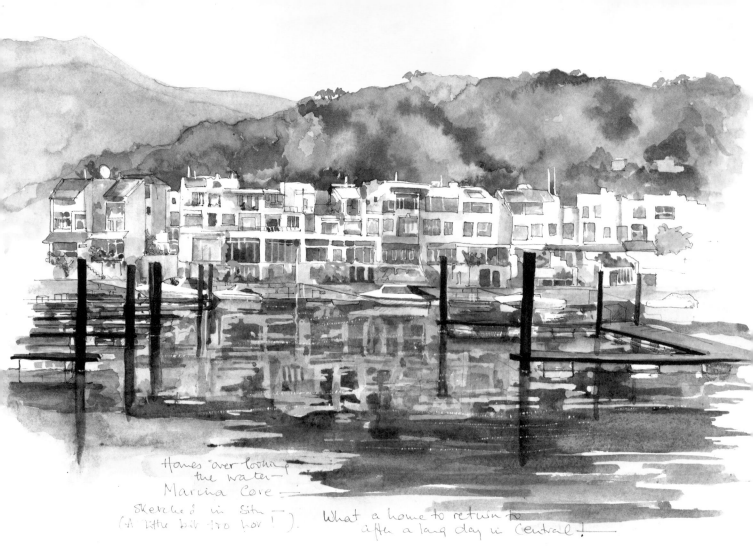

Homes "over looking"
the water
Marina Cove—
sketched in Situ—
(A little bit too hor!). What a home to return to
 after a long day in Central!

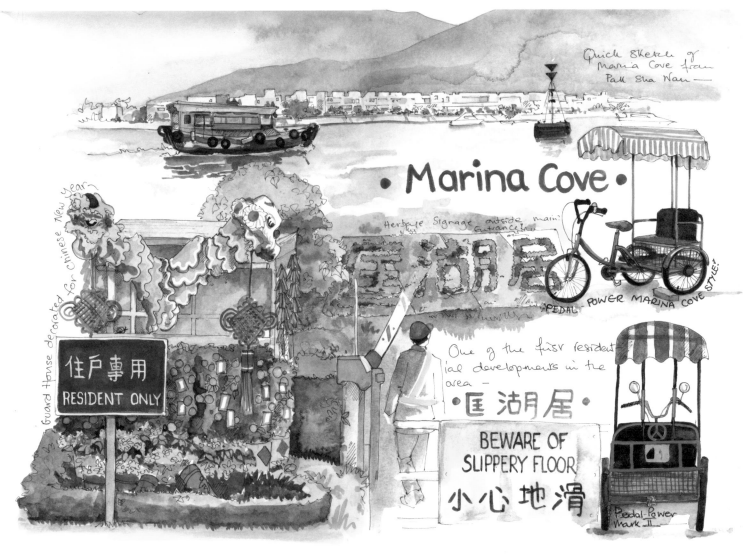

Quick sketch of Marina Cove from Pak Sha Wan —

• Marina Cove •

Hedge Signage outside main Entrance —

PEDAL-POWER MARINA COVE STYLE!

Guard House decorated for Chinese New Year —

住戶專用
RESIDENT ONLY

One of the first residential developments in the area —

• 匡湖居 •

BEWARE OF
SLIPPERY FLOOR
小心地滑

Pedal-Power Mark II —

獅子會自然教育中心
LIONS NATURE EDUCATION CENTRE
TSIU HANG, SAI KUNG.

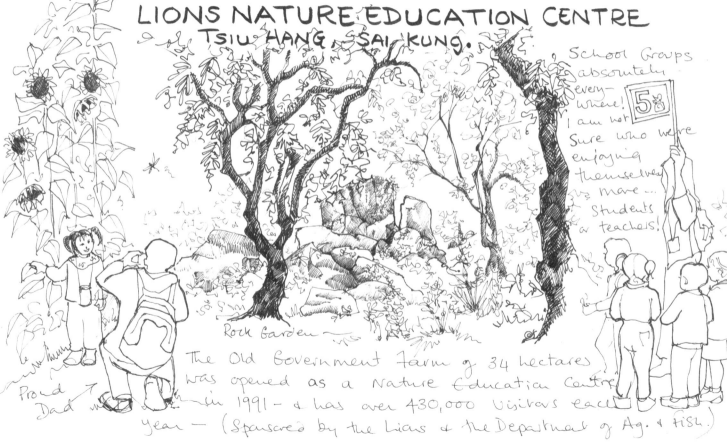

School Groups absolutely every-where! I am not sure who were enjoying themselves more... Students or teachers!

Rock Garden

Proud Dad

The Old Government Farm of 34 hectares was opened as a Nature Education Centre in 1991 — & has over 430,000 visitors each year — (Sponsored by the Lions & the Department of Ag. & Fish.)

香 港農民的稻米耕種時間表

RICE FARMERS' WORKING SCHEDULES (extract taken from an Educational Poster)

MAY	JUNE	JULY	AUG	SEPT	OCT	NOV

伍	陸	柒	捌	玖

SOWING TRANSPLANTING.

Wood & wire rake

VANISHING INDUSTRIES once seen in the Sai kung Area—

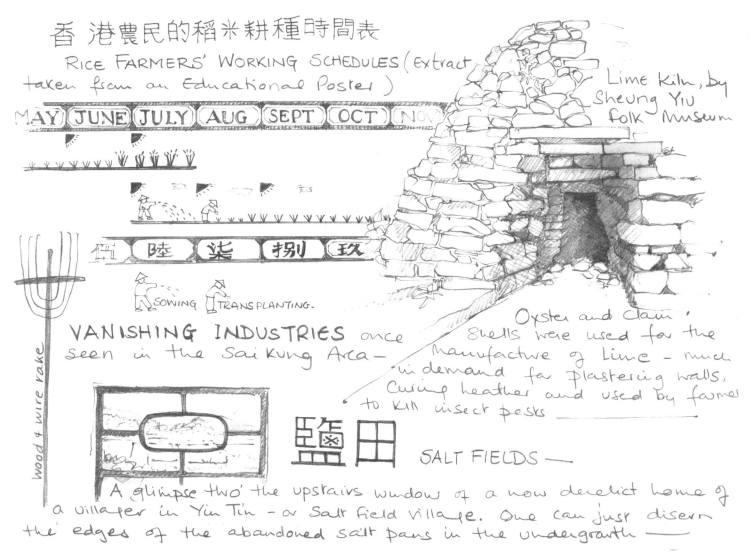

Lime Kiln, by Sheung Yiu folk Museum

Oyster and Clam Shells were used for the manufacture of Lime — much in demand for plastering walls, Curing heather and used by farmer to kill insect pests ————

鹽田

SALT FIELDS —

A glimpse thro' the upstairs window of a now derelict home of a villager in Yim Tin — a Salt field village. One can just discern the edges of the abandoned salt pans in the undergrowth —

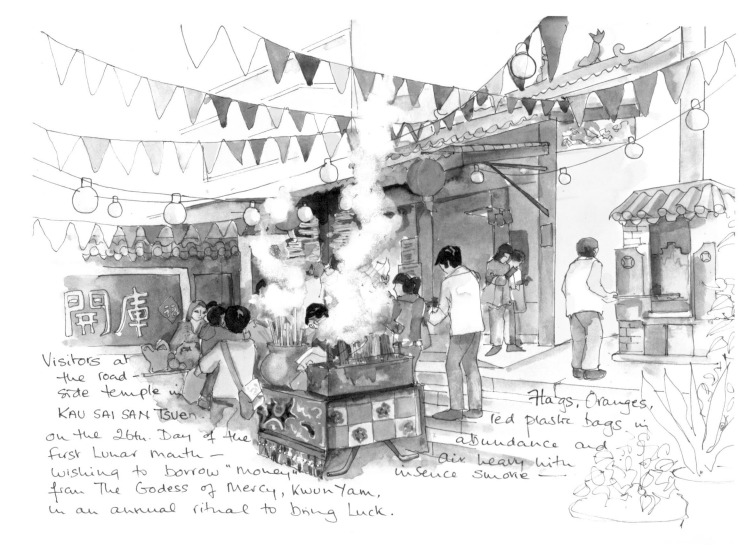

Visitors at
 the road-
 side temple in
 KAU SAI SAN TSUEN.
on the 26th. Day of the
First Lunar Month —
 wishing to borrow "money"
 from The Godess of Mercy, Kwun Yam,
 in an annual ritual to bring Luck.

Flags, Oranges,
 red plastic bags in
 abundance and
 air heavy with
 insence smoke —

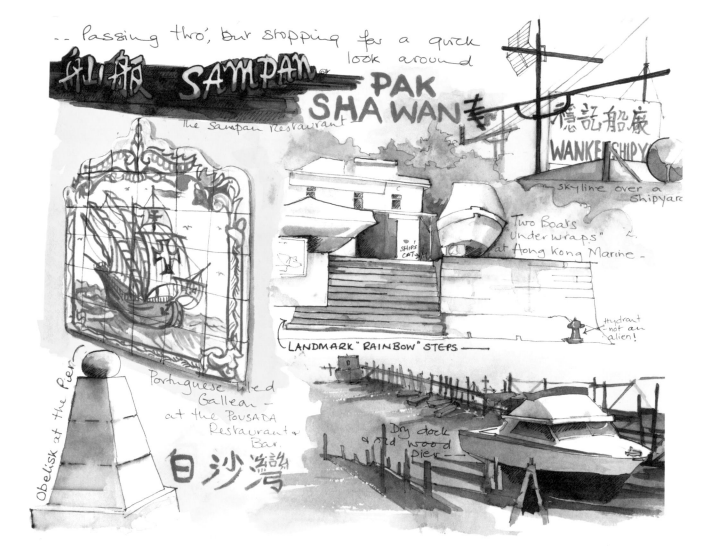

.. passing thro', but stopping for a quick look around

杉舨 SAMPAN

the Sampan Restaurant

PAK SHA WAN

億記船廠

WANKEI SHIPY.

skyline over a shipyard

"Two Boats Under wraps" at Hong Kong Marine –

SHIPS CAT

LANDMARK "RAINBOW" STEPS —

Hydrant – not an alien!

Obelisk at the Pier

Portuguese tiled Galleon – at the POUSADA Restaurant & Bar.

白沙灣

Dry dock & old wood pier –

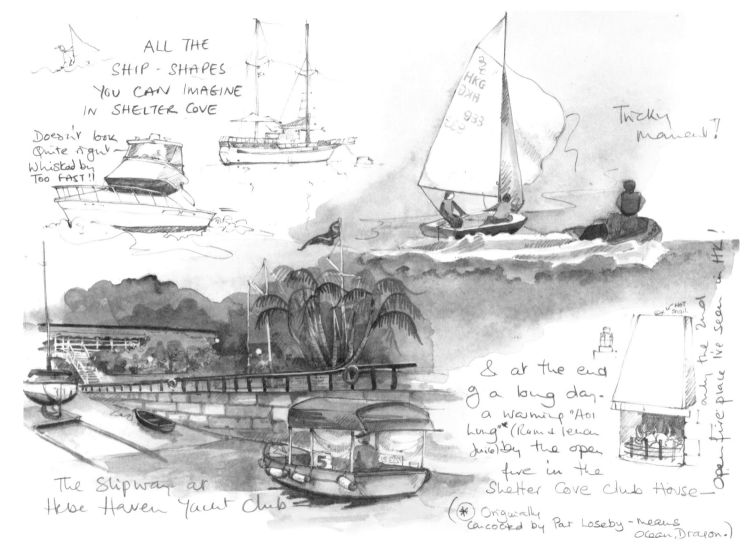

ALL THE
SHIP - SHAPES
YOU CAN IMAGINE
IN SHELTER COVE

Doesn't look
Quite right—
Whisked by
TOO FAST!!

HKG
DXH
933

Tricky
moment!!

& at the end
of a long day—
a warming "Hoi
Lung"* (Rum & lemon
Juice) by the open
fire in the
Shelter Cove Club House—

HOT
snail.

It's only the 2nd one I've seen in HK!
Open fire place I've seen in HK!

The Slipway at
Hebe Haven Yacht Club—

(*) Originally
Concocted by Pat Loseby—means
Ocean Dragon.)

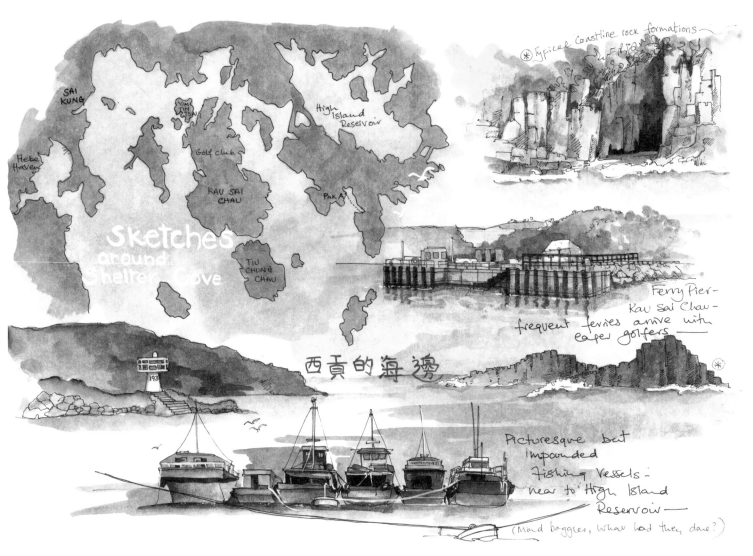

Sketches
around
Shelter Cove

SAI KUNG

Hebe Haven

YIM TIN TSAI

Golf Club

KAU SAI CHAU

High Island Reservoir

Pak A

TIU CHUNG CHAU

193

西貢的海邊

※ Typical coastline rock formations

Ferry Pier - Kau Sai Chau - frequent ferries arrive with eager golfers

※

Picturesque but impounded fishing vessels - near to High Island Reservoir -

(Mind boggles, what had they done?)

Dilapidated, but updated, notice near Pak A —

WARNING

The sea area marked by
yellow buoys or posts
is a fish culture zone
Unauthorized vessels are prohibited
Pollution of the zone is an offence.

Director of Agriculture, Fisheries & Conservation

警告

* These three
Ferocious
Guard dogs
barely gave
us a second
glance — let
alone a bark —

(obviously recognised us
for what we were,
just toothless, inn-
ocuous day-trippers!)

• FISH FARMS •

SPRAWLING,
LOW RISE, CLUTTERED, INTRIGUING,
communities that abound
in the off-shore waters
around SAI KUNG —

漁場

Traditional
wicker
BASKETS
& A
lonely
ORANGE
PLASTIC
BOX,
among a
myriad of
bright
blue plastic
barrels —

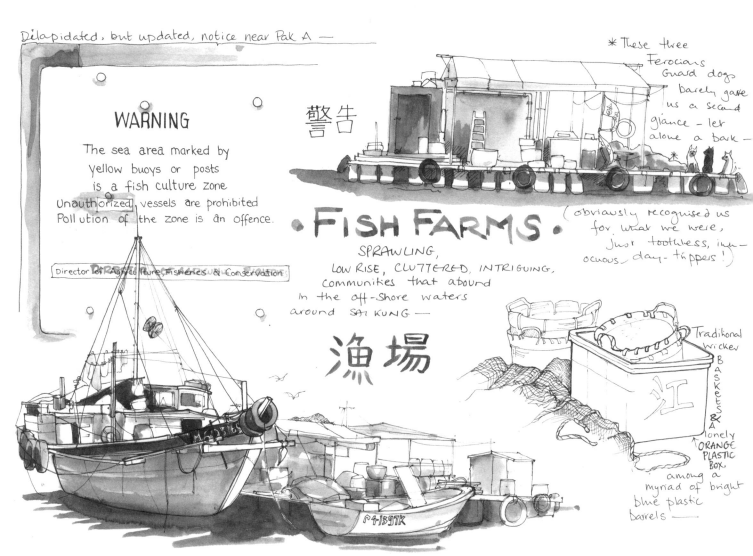

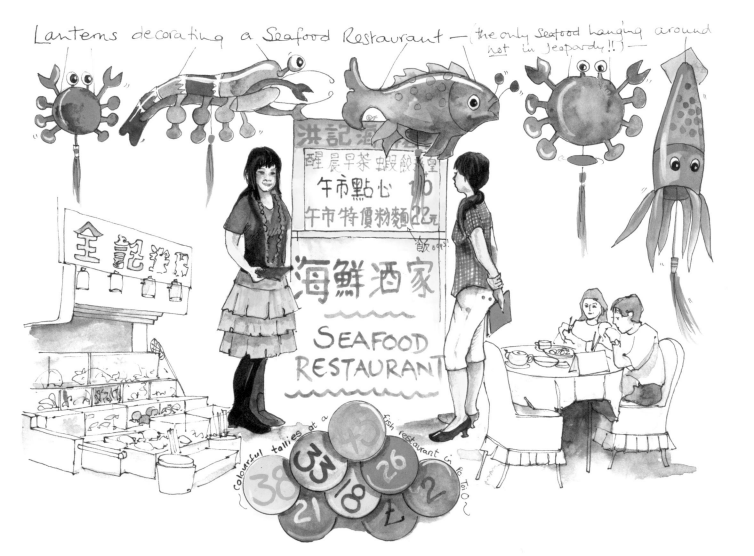

Lanterns decorating a Seafood Restaurant — (the only seafood hanging around not in Jeopardy!!) —

洪記海鮮
醒晨早茶 蝦餃鳳皇
午市點心 10
午市特價粉麵 22元
飲 8.9%

海鮮酒家
SEAFOOD
RESTAURANT

全記鮮魚

colourful tallies at a fish restaurant in Po Toi O

45 33 26 38 18 2 21 七

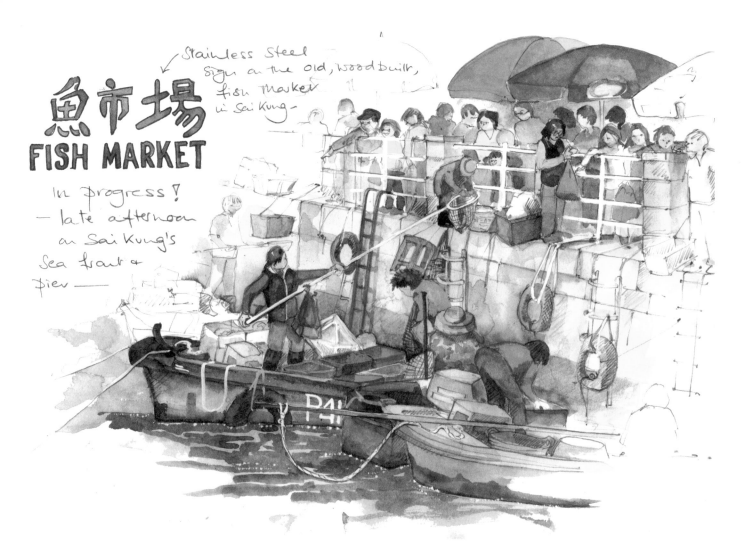

魚市場
FISH MARKET

Stainless steel
sign on the old, wood built,
fish market
in Sai Kung.

In progress!
— late afternoon
on Sai Kung's
Sea front &
pier —

Along the Waterfront — Tourists, diners & dreamers; School kids with Assignments, Sampans, Egrets; Men with trolleys, Myriads of brollies.. & Women in Wellies!

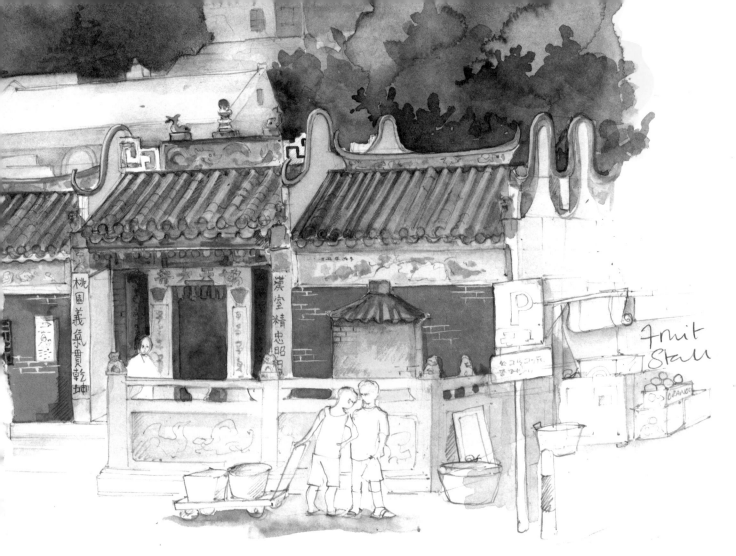

Fruit
Stall

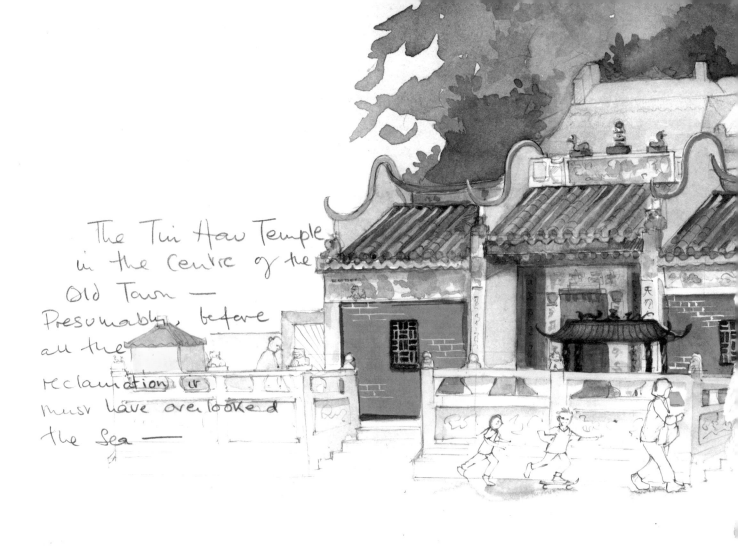

The Tin Hau Temple
in the Centre of the
Old Town —
Presumably, before
all the
reclamation it
must have overlooked
the Sea —

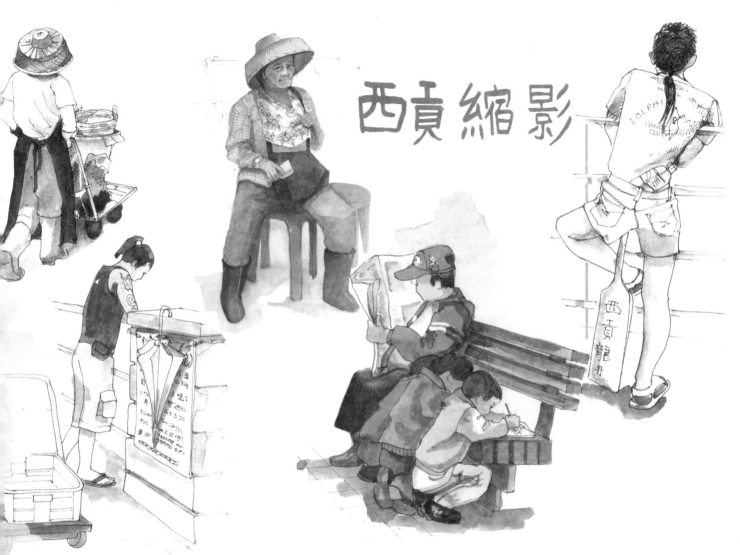

西貢縮影

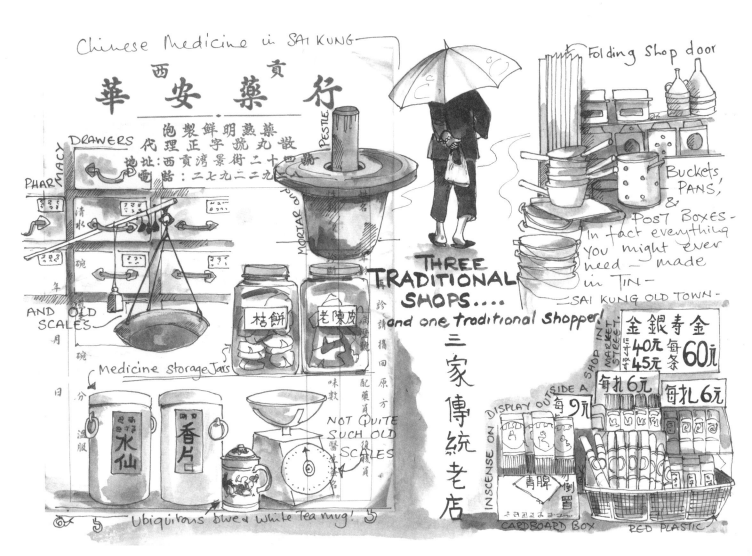

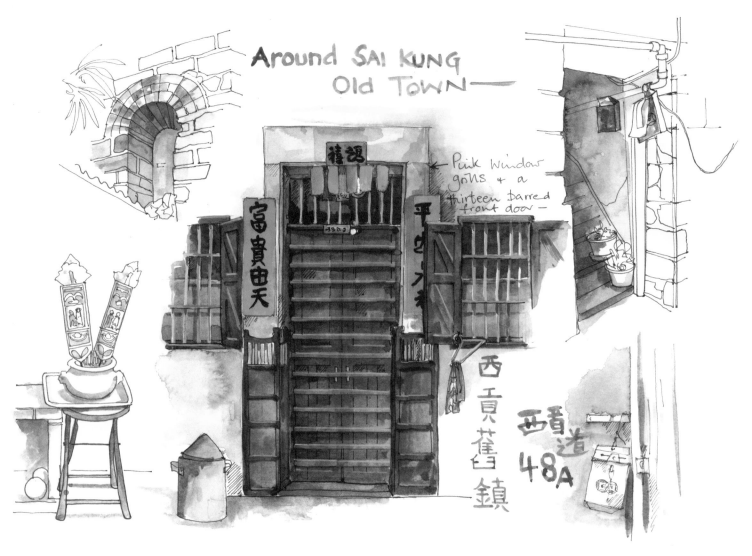

Around SAI KUNG
Old Town—

禮讓

富貴由天

平安......

Pink window
grills + a
thirteen barred
front door—

西貢舊街鎮

西貢道
48A

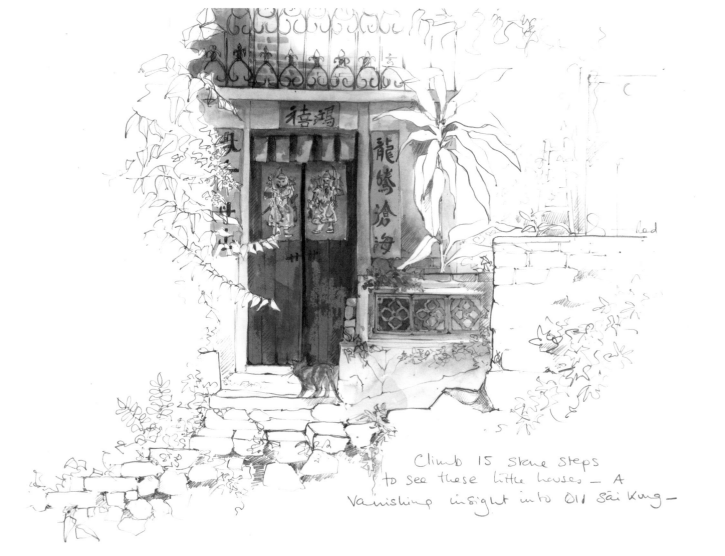

禧鴻

龍蟠滄海

Climb 15 stone steps
to see these little houses — A
Vanishing insight into Old Sai Kung —

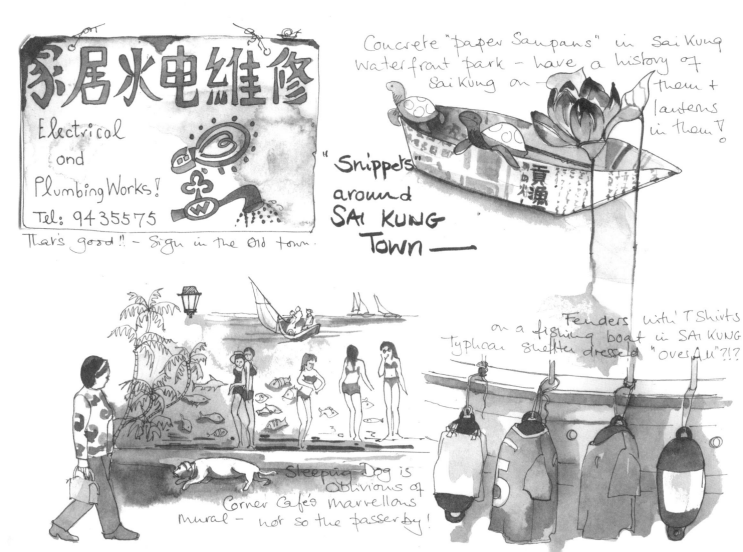

家居水电維修

Electrical
and
Plumbing Works!
Tel: 9435575

That's good!! - Sign in the Old town.

Concrete "paper Sampans" in Sai Kung
Waterfront park - have a history of
Sai Kung on them + lanterns in them!

"Snippets" around SAI KUNG Town —

貢漁

Fenders with T Shirts
on a fishing boat in SAI KUNG
Typhoon Shelter dressed "OverAll"?!?

Sleeping Dog is Oblivious of
Corner Cafe's marvellous
mural - not so the passerby!

HUNG KEE SEAFOOD RESTAURANT

HONEYMOON DESSERT

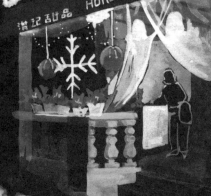

SAI
KUNG
NIGHT LIGHTS

POETS
GOING FROM BAD TO VERSE

霓虹燈

XTREME

Steamers

Est. 1988

The Duke

TS CONTEST
Cowboy

The Duke
Mon-Fri
12:00

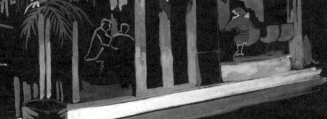

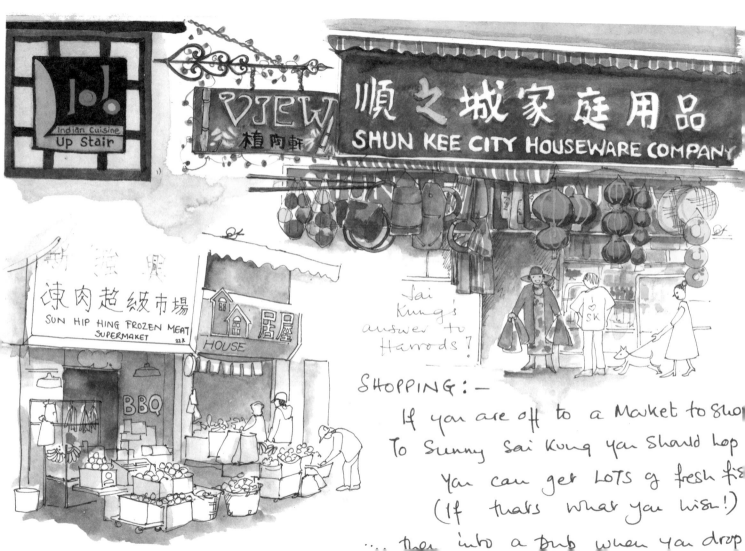

Indian Cuisine Up Stair

VIEW 植物軒

順之城家庭用品
SHUN KEE CITY HOUSEWARE COMPANY

新鮮肉
凍肉超級市場
SUN HIP HING FROZEN MEAT
SUPERMAKET 22元

居屋
HOUSE

BBQ

Sai Kung's answer to Harrods?

SHOPPING :—

If you are off to a market to shop
To Sunny Sai Kung you should hop
 You can get LOTS of fresh fish
 (If that's what you wish!)
... then into a pub when you drop

西貢的商業

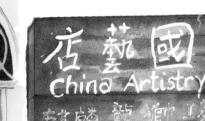

A Serendipity of Business Signs

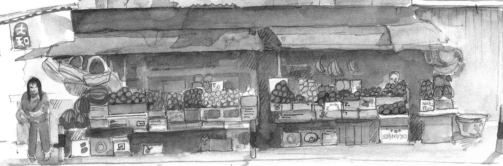

Fruit shop by the side of the Tin Hau Temple

Quick pencil sketch - Traffic hooting all around wk wash added later

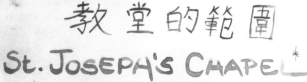

教堂的範圍
St. Joseph's Chapel
Yim Tin Tsai Village

This Chapel was built 150 years ago when Catholic Missionaries settled on the Island. It had a School attached — now a Museum.

SIDE DOOR - with Christmas Decorations still dangling on a near by tree — (well, it is only January!)

* Received the UNESCO Asia-Pacific Award of Merit in 2005

The Landmark Church overlooking the Typhoon Shelter & Old Sai Kung —

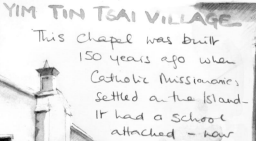

Unusual little Chapel in the Romantic setting of Ido Garden, near Marina Cove, from above, peeping thro' the foliage —

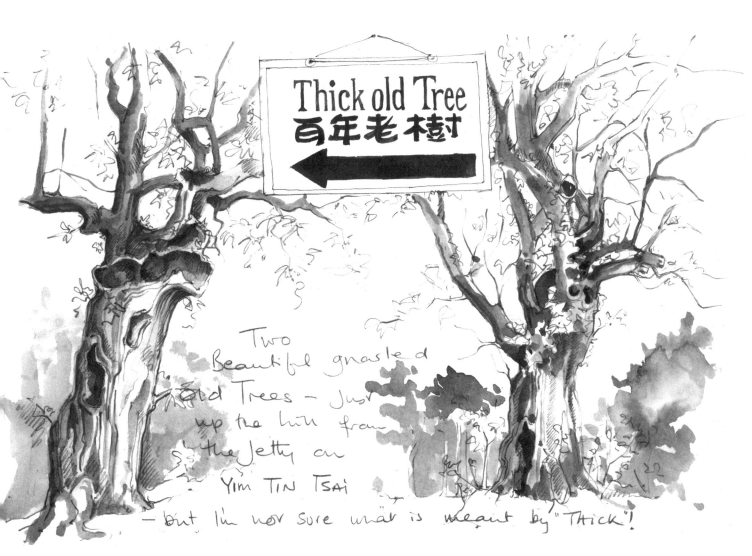

Thick old Tree
百年老樹

Two
Beautiful gnarled
Old Trees — Just
up the hill from
the Jetty on
Yim Tin Tsai
— but I'm not sure what is meant by "Thick"!

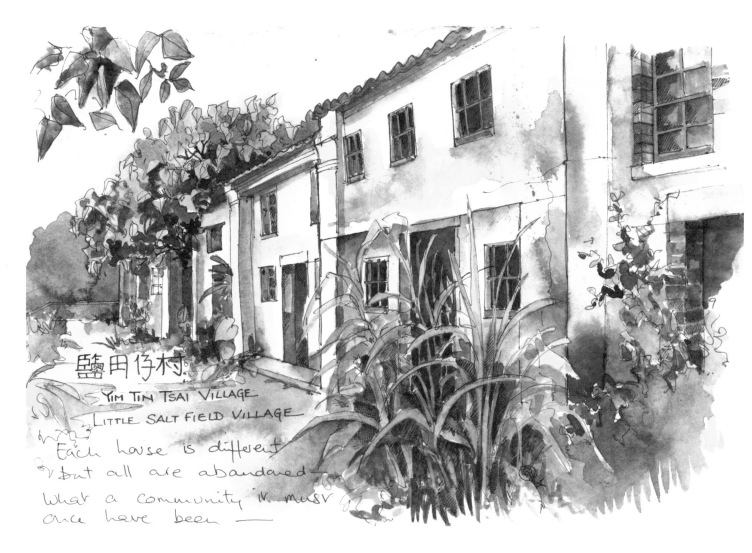

鹽田仔村
YIM TIN TSAI VILLAGE
LITTLE SALT FIELD VILLAGE

Each house is different
but all are abandoned —
what a community it must
once have been —

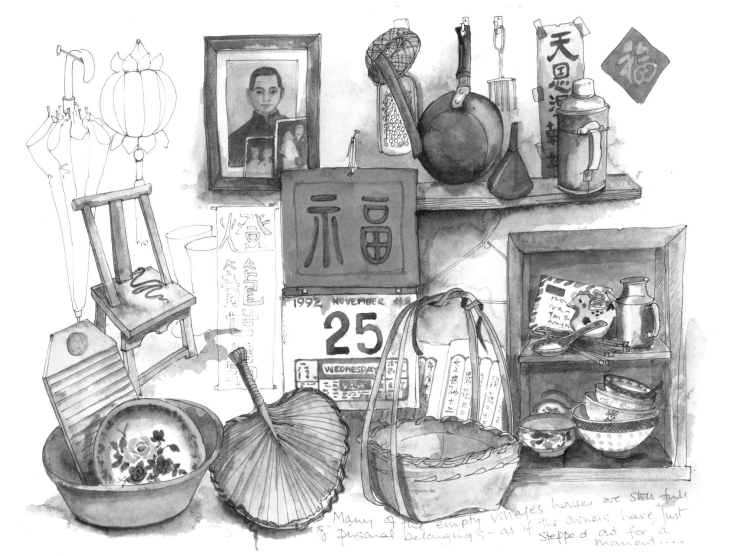

天恩浩萬

福

火燈

1992 NOVEMBER
25
WEDNESDAY

Many of the empty villages houses are still full of personal belongings - as if the owners have just stepped out for a moment....

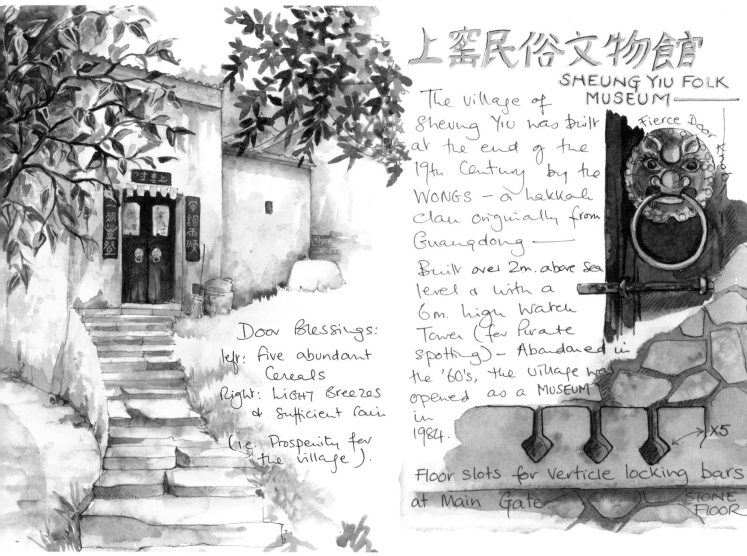

上窯民俗文物館
SHEUNG YIU FOLK MUSEUM

The village of Sheung Yiu was built at the end of the 19th Century by the WONGS — a hakkah clan originally from Guangdong —

Built over 2m. above sea level & with a 6m. high watch Tower (for Pirate spotting) — Abandoned in the '60's, the village was opened as a MUSEUM in 1984.

Fierce Door

Floor slots for verticle locking bars at Main Gate.

x5

STONE FLOOR

Door Blessings:
left: Five abundant Cereals
Right: Light Breezes & Sufficient rain

(i.e. Prosperity for the village).

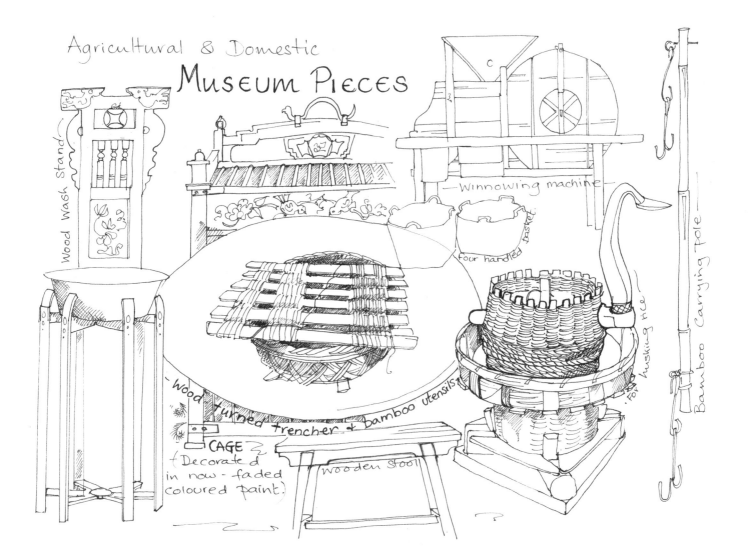

Agricultural & Domestic

Museum Pieces

Wood Wash Stand

Winnowing machine

Four handled basket

Bamboo Carrying Pole

For husking rice

- Wood turned trencher + bamboo utensils

CAGE
(Decorated in now-faded coloured paint)

Wooden Stool

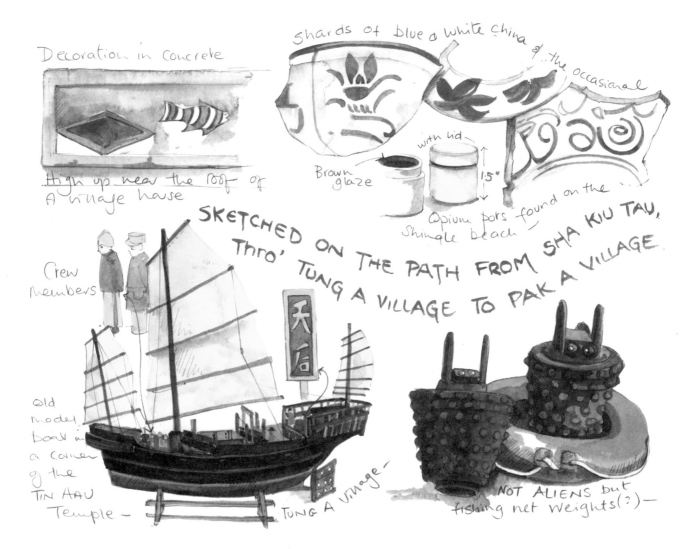

Decoration in concrete

High up near the roof of A village house

Shards of blue & white china & the occasional

Brown glaze

with lid

1.5"

Opium pots found on the shingle beach

SKETCHED ON THE PATH FROM SHA KIU TAU, THRO' TUNG A VILLAGE TO PAK A VILLAGE

Crew members

Old model boat in a corner of the TIN HAU Temple —

TUNG A Village —

NOT ALIENS but fishing net weights(?) —

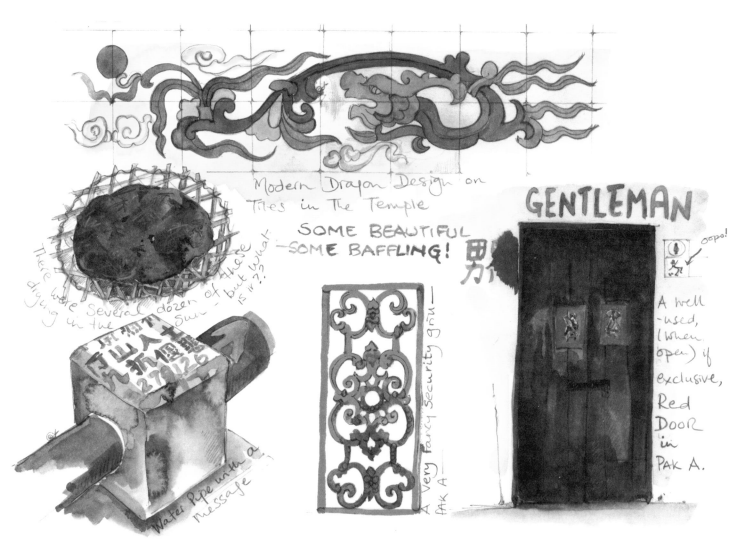

Modern Dragon Design on Tiles in The Temple

SOME BEAUTIFUL —SOME BAFFLING!

男

There were several dozen of those digging in the sun — but what is it??

Water Pipe with a message

A very fancy Security grill — PAK A

GENTLEMAN

Oops!

A well-used, (when open) if exclusive, Red DOOR in PAK A.

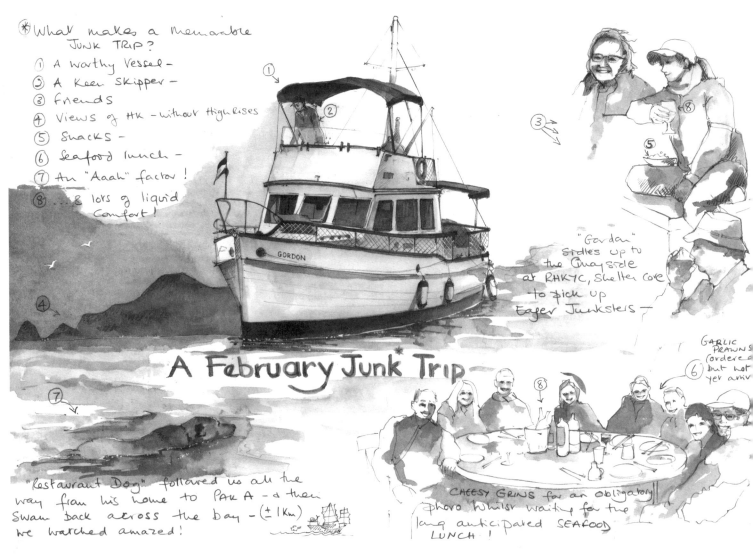

✱ What makes a Memorable
 JUNK TRIP?
① A Worthy Vessel —
② A Keen Skipper —
③ Friends
④ Views of HK — without Highrises
⑤ Snacks —
⑥ Seafood lunch —
⑦ An "Aaah" factor !
⑧8 lots of liquid
 Comfort !

GORDON

A February Junk Trip

"Gordon" sidles up to
the Quayside
at RHKYC, Shelter Cove
to pick up
eager Junksters —

GARLIC PRAWNS (ordered but not yer arriv

"Restaurant Dog" followed us all the
way from his home to PAK A — & then
swam back across the bay — (± 1 Km)
we watched amazed !

CHEESY GRINS for an obligatory
photo whilst waiting for the
long anticipated SEAFOOD
LUNCH !

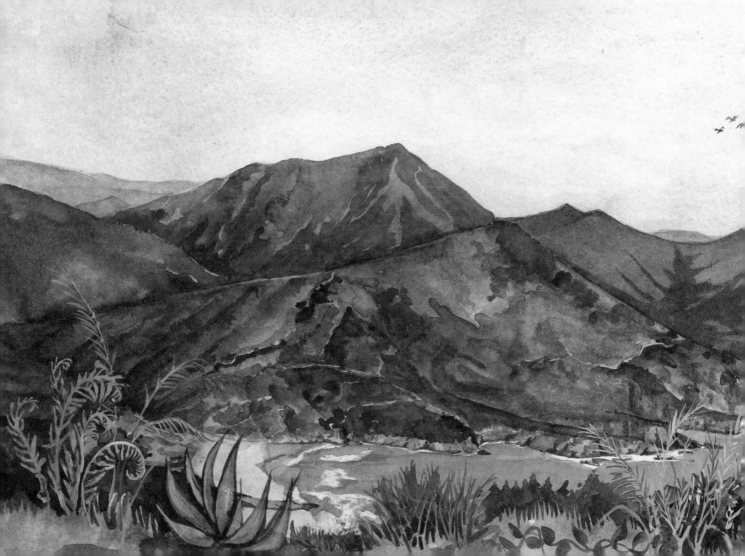

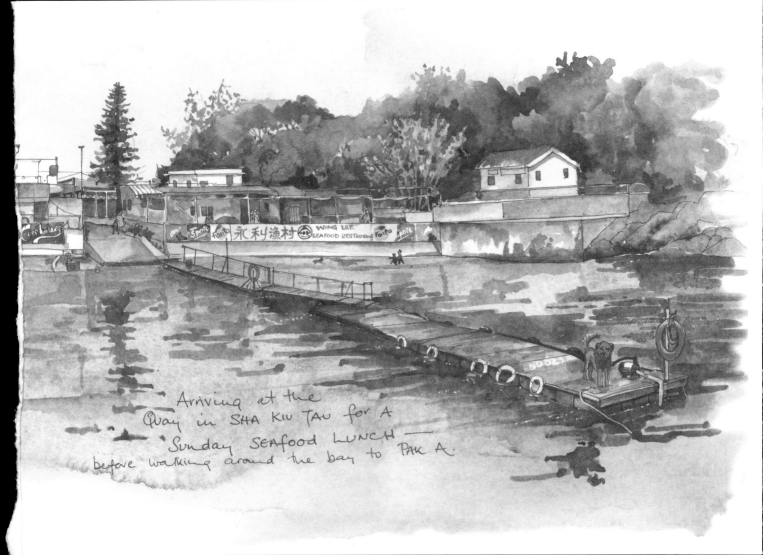

Arriving at the
Quay in SHA KIU TAU for A
— Sunday SEAFOOD LUNCH —
before walking around the bay to PAK A.

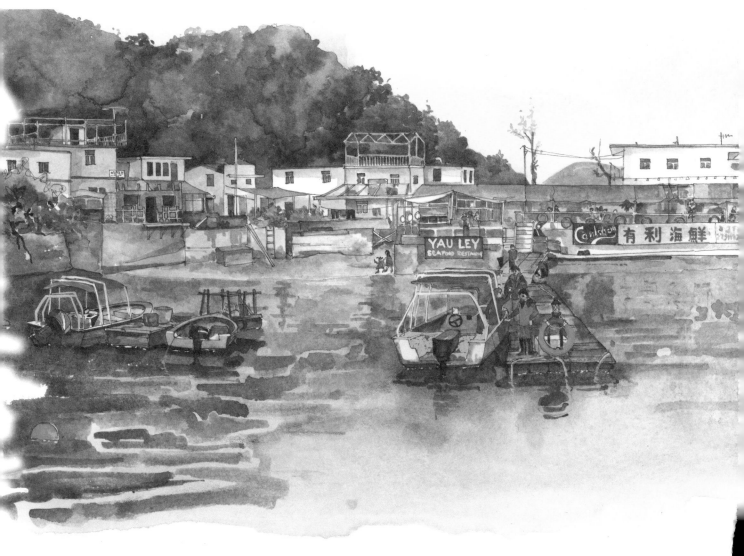

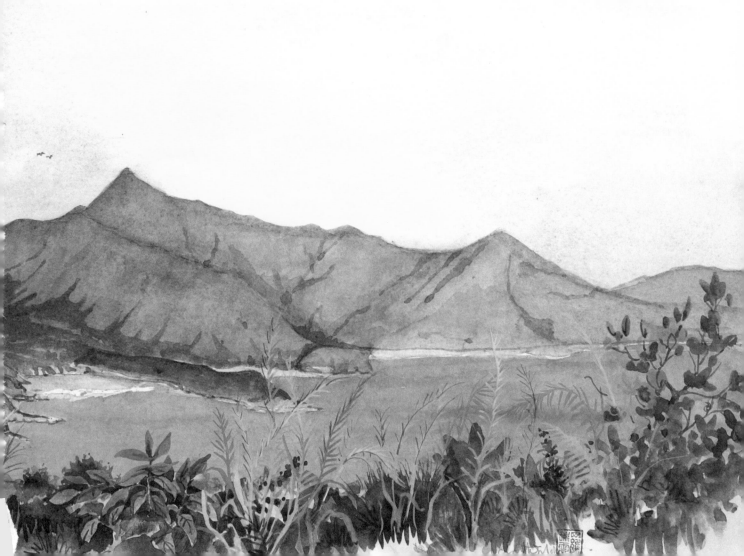

On the footpaths of SAI KUNG'S County Parks —

WALKING THE PETS!

麥理浩徑四段
←

露營地點
←

在西貢自然教育徑

HIKE FASHION —
SAI KUNG

Crossing the Rickety Bridge in Ham Tin —

Hazel on her way to Pak Sha O — unconventionally dressed for a Country Walk!

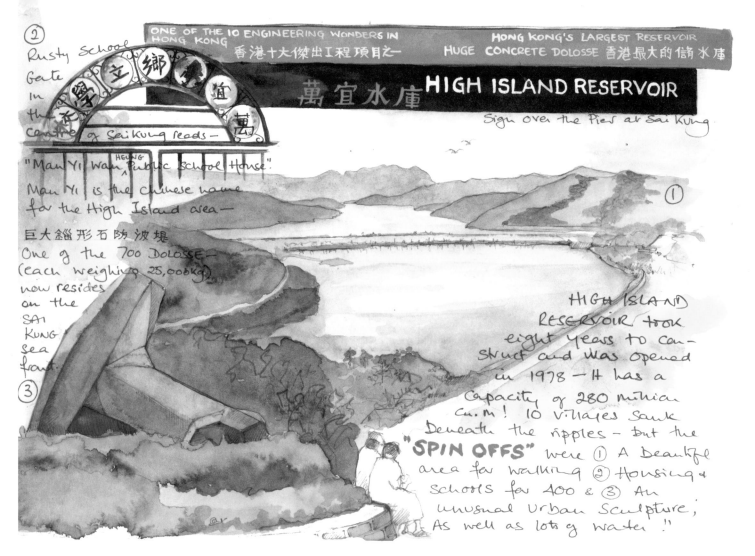

萬宜水庫 HIGH ISLAND RESERVOIR

Sign over the Pier at Sai Kung

② Rusty School Gate in the Centre of Sai Kung reads —

"Man Yi Wan Heung Public School House".

Man Yi is the Chinese name for the High Island area —

巨大錨形石防波堤
One of the 700 DOLOSSE — (each weighing 25,000kg) now resides on the SAI KUNG sea front.

③

①

HIGH ISLAND RESERVOIR took eight years to construct and was opened in 1978 — It has a capacity of 280 million cu.m! 10 villages sank beneath the ripples — But the "SPIN OFFS" were ① A beautiful area for walking ② Housing & schools for 400 & ③ An unusual urban sculpture; As well as lots of water !"

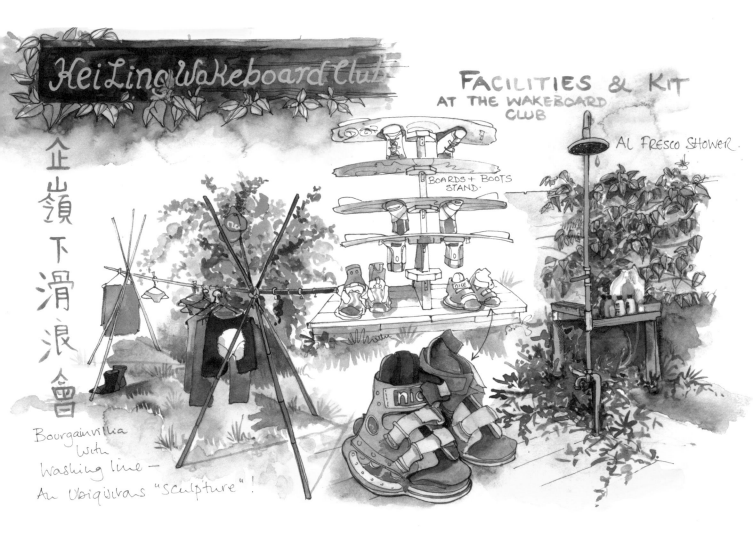

Hei Ling Wakeboard Club

FACILITIES & KIT
AT THE WAKEBOARD CLUB

企嶺下滑浪會

BOARDS + BOOTS STAND.

AL FRESCO SHOWER.

nice

Bourgainvilia
with
washing line —
An Ubiquitous "Sculpture"!

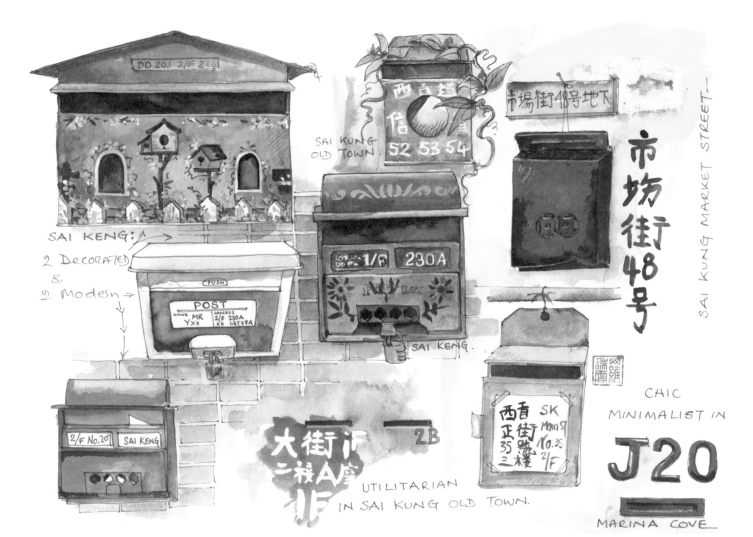

DD 203 2/F 244

西貢道
信
52 53 54

SAI KUNG
OLD TOWN

市場街48号地下

市場街48号

SAI KUNG MARKET STREET

SAI KENG:
2 Decorated
&
2 Modern →

PUSH

POST
NAME MR
Y×× ADDRESS 2/F 230A
×× LOT××A

LOT××
DD×× 1/F 230A

POST BOX

SAI KENG

2/F No.20 SAI KENG

大街 1F
二後 A 寓
1F

2B

香 西 街 SK
正 貢 號 MAIN ST
35 街 三 No.35
三 35 樓 2/F

CHIC
MINIMALIST IN

J20

MARINA COVE

UTILITARIAN
IN SAI KUNG OLD TOWN.

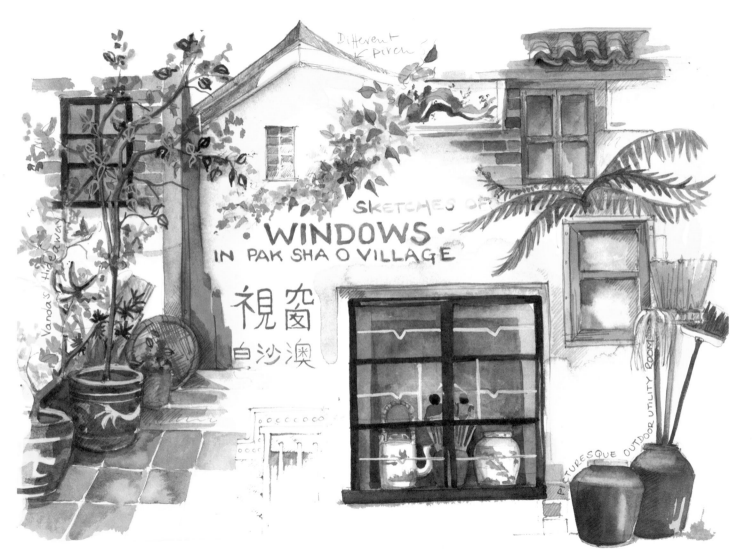

Different
pitch

SKETCHES OF

· WINDOWS ·
IN PAK SHA O VILLAGE

視窗
白沙澳

Vanda's Hideaway

PICTURESQUE OUTDOOR UTILITY ROOM

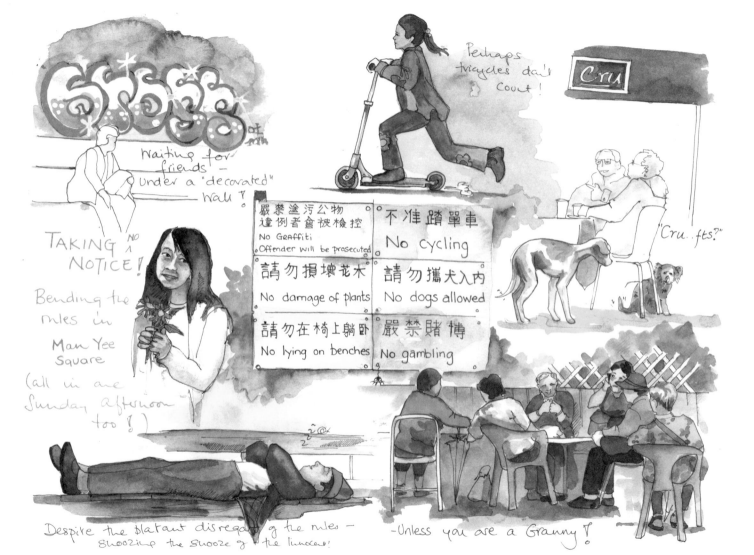

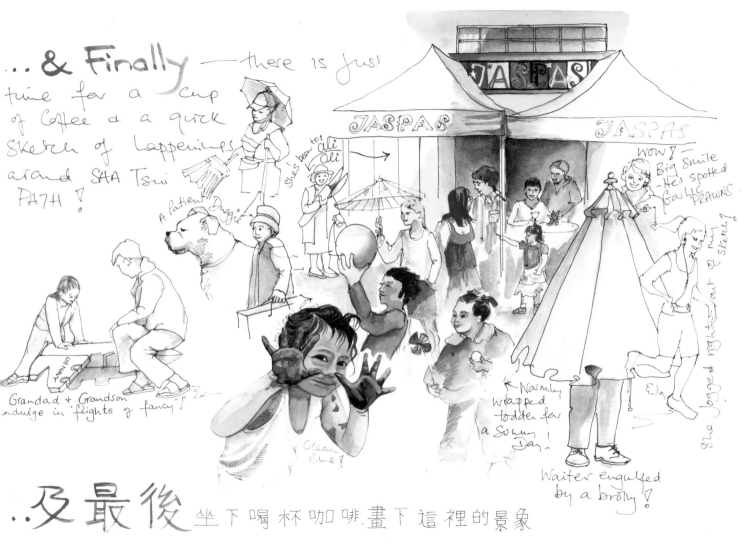

... & Finally — there is just time for a cup of coffee & a quick sketch of happenings around SHA TSUI PATH!

A patient Doggie!

She's been to: Ali

JASPAS
JASPAS
JASPAS

Wow! — Big smile — He's spotted GARLIC PRAWNS!

She jogged right in & out & steered!

Grandad & Grandson indulge in flights of fancy!

Ocean Blue!

↖ Warmly wrapped toddler for a Sunny Day!

Waiter engulfed by a brolly!

..及最後 坐下喝杯咖啡,畫下這裡的景象

..Now a page for you.......